Charles Herbert Moore

LANDSCAPE PAINTER

Charles Herbert Moore

LANDSCAPE PAINTER

BY

FRANK JEWETT MATHER, JR.

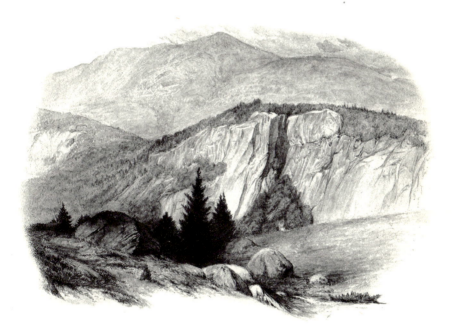

1957

PRINCETON, NEW JERSEY
PRINCETON UNIVERSITY PRESS

PUBLISHED FOR THE

DEPARTMENT OF ART AND ARCHAEOLOGY

PRINCETON UNIVERSITY

Published in memory of
Frank Jewett Mather, Jr.
1868-1953

Department of Art and Archaeology
Princeton University

EDITOR'S PREFACE

This MONOGRAPH on Charles Herbert Moore was the last work of Frank Jewett Mather, Jr., noted art critic, writer, connoisseur, museum director, and teacher. Apart from a few minor revisions of fact, which he himself would undoubtedly have welcomed had he lived, his work is published almost as he left it in the last years of his life. The revisions were suggested mainly by Arthur Pope, Professor-Emeritus of Fine Arts at Harvard University, who knew Moore and wrote the article on him in the *Dictionary of American Biography*, and by Professor David H. Dickason of Indiana University, author of the chief book on the American Pre-Raphaelites and their influence. The editor wishes to offer here his warm thanks to Professors Pope and Dickason, and also to Mr. Gillett Griffin, Mrs. Helen Van Zandt, Mrs. Helen Wright, and Mrs. Diane M. Lee for their kind and expert aid.

Special thanks must be given to Mrs. Mather whose unfailing help in preparing her husband's manuscript for publication has been indispensable. From Mrs. Mather we know that her husband had planned to express in the present book his profound appreciation of the assistance given to him by Charles Moore's daughter, the late Miss Elizabeth Huntington Moore, and by his niece, Mrs. Theodore H. Krueger. Miss Elizabeth Moore not only supplied much information about her father's life and career but, while this monograph was being written, presented many of his paintings and other works to the Art Museum of Princeton University of which Dr. Mather was Director from 1922 to 1946.

When Frank Mather died, he left his manuscript untitled. Although in it he briefly dealt with Moore as teacher, critic, and historian, as well as painter, it is clear that Mather himself was interested in Moore primarily as a landscape painter.

The monograph is published in memory of its author by the Department of Art and Archaeology, Princeton University, of which he was an active member from 1910 to 1933 and professor-emeritus until his death in 1953 at the age of eighty-five. Several of the present members of the faculty of that Department were his pupils as well as his friends, and welcome this opportunity of recording, in the preface to his last work, their enduring affection, admiration, and respect.

Donald D. Egbert

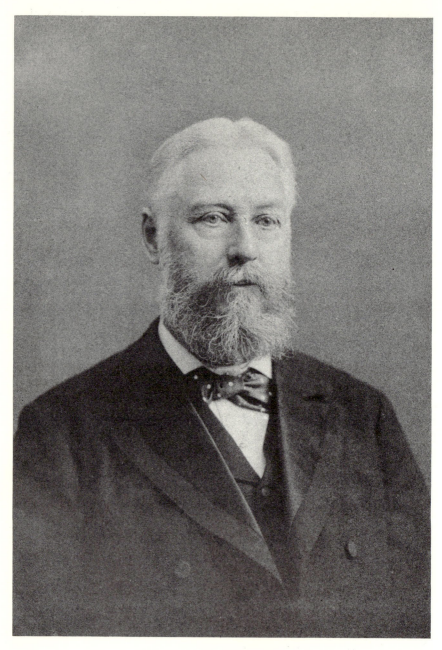

Charles Herbert Moore

AUTHOR'S INTRODUCTION

SEVERAL YEARS AGO I first saw a painting by Charles Herbert Moore, at the Thomas Cole Studios, Catskill, N.Y. Cole's granddaughter sold me in good faith this delightful little landscape (Fig. 1) as a Cole. As I lived with it, I soon saw it was not a Cole, but later, and in many ways better, certainly a painting rather of the 1860's than of the 1830's or 1840's. It had finesses of color and a large constructive expression that Cole never so fully commanded. It was by an unknown landscape painter on the whole abler, at least more advanced in his art, than were George Inness and Homer D. Martin at their beginnings.

The mystery was solved gradually and partly by a happy chance. The little oblong canvas was untidily glued to a pasteboard. I had it taken off for rebacking, and read on the reverse of the canvas the strongly written inscription: "Charles H. Moore, Caaterskill, N.Y." Here was a name for my great unknown. I looked up Moores. The all-including Tuckerman did just name a Moore as a promising young landscape painter. I sought biographical dictionaries. Yes, Charles Herbert Moore, Harvard professor and museum director, whose authoritative books on the subject of Renaissance and Gothic architecture had been almost required reading for the art-loving intelligentsia, had been a landscape painter in his pre-Harvard days, and a good landscape painter. I began to seek out his landscapes, and as I located and studied the thirty or so in various mediums which are the basis of this study, I felt in all of them that strenuous and searching intelligence, that strength and delicacy of attitude which distinguished the little canvas I had bought in error as a Cole.

Here was a landscape painter revealing in his twenties a taste equal to Homer Martin's and an intelligence superior to George Inness', diverted into teaching and criticism in his early thirties, ending as an apostle of the approach to the appreciation of art through practice, and as an authority on mediaeval architecture.

This, as it seemed to me, thwarted, however distinguished, career excited my curiosity and sympathy, seemed to invite understanding and interpretation. There seemed to be reason enough for a little book, and here it is.

While my aim has been simply to commemorate an American artist of exceptional merit, whose paintings and etchings have fallen into undue oblivion, I have come incidentally upon much interesting material about his later career as teacher, writer and museum director. This I have not withheld from the reader. The result while hardly a full length portrait, may at least serve as a credible sketch of a most versatile talent.

Frank Jewett Mather, Jr.

CONTENTS

Editor's Preface vii

Author's Introduction ix

List of Illustrations xii

Chapter I. Boyhood and First Steps in Painting 3

Chapter II. Paintings of the Early 1860's 10

Chapter III. With the American Pre-Raphaelites 16

Chapter IV. Marriage. Move to Catskill. His Activities Described for Charles Eliot Norton 23

Chapter V. Moore's Pre-Raphaelite Paintings, Drawings and Etchings 28

Chapter VI. Studies of Mount Washington. Watercolors of the Early 1870's. Mount Kearsarge 37

Chapter VII. At Harvard. Teaching in the Scientific School. Temporarily Ceases to Paint 44

Chapter VIII. European Wanderjahre. Working with Ruskin. The Mezzotints 48

Chapter IX. Building up an Art Department 57

Chapter X. Moore's Architectural Studies. Museum Director 64

Chapter XI. Home at "Wellfield." Book on English Church Architecture. Critical Articles. Last Days 72

Appendices. 1. A Note on Manuscript Sources, Prepared by Frank Jewett Mather, Jr. 79

 2. Editor's Note on the Chief Collections of Moore's Work as Artist 81

Index 83

LIST OF ILLUSTRATIONS

Title page. *Mount Washington* (watercolor, unfinished). Art Museum, Princeton University. 9⅞ x 12⅞ inches. Gift of Miss Elizabeth Moore.

Dedication page. Frank Jewett Mather, Jr.

Frontispiece. Charles Herbert Moore.

Fig. 1. *Upland Pasture* (oil on canvas). Art Museum, Princeton University, Princeton, N.J. 7¹⁵⁄₁₆ x 17¹¹⁄₁₆ inches. Originally inscribed on back *Charles H. Moore, Caaterskill, N.Y.* Bought from Thomas Cole Studios, Catskill, N.Y.

Fig. 2. *Juvenile Landscape* (oil on canvas). Owned by the artist's nephew, Mr. Howard L. Moore, Putney, Stratford, Conn. 23½ x 33½ inches. Possibly a copy made by Moore after a work by another painter.

Fig. 3. *In Berkshire County* (oil on canvas). 12 x 9 inches. On permanent loan to the New-York Historical Society from the New York Public Library (where it is titled *Landscape Study, Trees and Rocks*). No. 34 in the catalogue of the Robert L. Stuart Collection of the New York Public Library which states that the painting was bought from the artist in 1859. In that year it had been exhibited in the National Academy as No. 806 under the title, *In Berkshire County.*

Fig. 4. *River View with Cattle* (oil on canvas). Owned by Mrs. Frank Van Rensselaer Phelps, White Plains, N.Y. 10 x 20 inches. Signed *C. H. M.*, and on back is written *C. H. Moore 1859.*

Fig. 5. *View on the Housatonic* (Currier and Ives lithograph). Art Museum, Princeton University. 13½ x 20½ inches.

Fig. 6. *Catskill Bywater* (oil on canvas). New York State Museum, Albany, N.Y. (where it is titled *Catskill Mountain Landscape*). 7 x 11½ inches. Signed and dated *C. H. M. 1861.*

Fig. 7. *The Upper Palisades* (oil on canvas). Art Gallery, Vassar College, Poughkeepsie, N.Y. 12 x 20 inches. Signed and dated *C. H. M. 1860.* Gift of Matthew Vassar to Vassar College in 1864.

Fig. 8. *Down the Hudson to West Point* (oil on canvas). Art Gallery, Vassar College. 20¼ x 30¼ inches. Gift of Matthew Vassar to Vassar College in 1864.

Fig. 9. *The Catskills in Spring* (oil on canvas). Art Gallery, Vassar College. 12 x 20¼ inches. Signed and dated *C. H. Moore. 1861.* Gift of Matthew Vassar to Vassar College in 1864.

Fig. 10. *Morning over New York* (oil on canvas). Art Gallery, Vassar College. 12 x 30 inches. Gift of Matthew Vassar to Vassar College in 1864.

Fig. 11. *Winter Landscape, Valley of the Catskill* (oil on canvas). Art Museum, Princeton University. 7 x 10 inches. Monogrammed and dated *C. H. M. 1866.* Acquired by F. J. Mather, Jr., after he had completed his manuscript for this book. The distant hills in this picture are those represented in Figs. 9 and 13.

Fig. 12. *Leeds Bridge* (oil on canvas). Art Museum, Princeton University. 11 x 16 inches. Monogrammed and dated *C. H. M. 1868.* Bought from the collection of Mrs. Juliana Force.

Fig. 13. *The Valley of the Catskill from Jefferson Hill* (pen drawing for etching). Art Museum, Princeton University. 5¼ x 8¼ inches. Signed and dated *C. H. Moore. 1869.* On the back is a long note (see main text on p. 34), and studies for Moore's monogram. Gift of the artist's daughter, Miss Elizabeth Moore.

Fig. 14. *Snow Squall* (watercolor). Art Museum, Princeton University. 5⅝ x 8¹⁵⁄₁₆ inches. Gift of Miss Elizabeth Moore.

Fig. 15. *Leeds Bridge* (pen drawing for etching). Owned by the estate of Miss Elizabeth Moore, Hartley Wintney, Basingstoke, Hampshire, England. 3⅛ x 5½ inches. Signed and dated *C. H. M. 1869.*

Fig. 16. *Pine Tree* (pen drawing, unfinished). Art Museum, Princeton University. 25¹¹⁄₁₆ x 20 inches. Dated *Catskill 1868.* Gift of Miss Elizabeth Moore.

Fig. 17. *Overgrown Wood Road* (etching). Art Museum, Princeton University. 2⅞ x 5½ inches. Signed and dated *C. H. Moore. 1869.* Gift of Professor Alfred M. Brooks to whom this and the two following etchings were presented by the artist.

Fig. 18. *Ledge and Spruces* (etching). Art Museum, Princeton University. 7 x 4¼ inches. Signed and dated *C. H. Moore. 1869*. Gift of Professor Alfred M. Brooks to whom it was presented by the artist.

Fig. 19. *Over Mountain Shoulders* (etching). Art Museum, Princeton University. 3½ x 5½ inches. Signed and dated *C.H. Moore. 1869*. Gift of Professor Alfred H. Brooks to whom it was presented by the artist.

Fig. 20. *Mount Washington* (pencil drawing with wash). Owned by Mrs. Theodore Krueger, Putney, Stratford, Conn. 12½ x 19½ inches. Dated *1869*.

Fig. 21. *White Mountain Country* (pencil drawing with wash). Fogg Art Museum, Harvard University, Cambridge, Mass. 15⅛ x 24⅛ inches.

Fig. 22. *White Mountains* (pencil drawing). Fogg Art Museum, Harvard University. 5¹⁵⁄₁₆ x 8¾ inches.

Fig. 23. *Mount Washington* (watercolor). Art Museum, Princeton University. 6¼ x 9 inches. Gift of Miss Elizabeth Moore. Monogrammed and dated *C. H. M. '72*.

Fig. 24. *Landscape* (watercolor). Fogg Art Museum, Harvard University. 7⅜ x 10⅝ inches.

Fig. 25. *Rocks by the Water* (watercolor). Fogg Art Museum, Harvard University. 5¼ x 7⅜ inches.

Fig. 26. *Mount Kearsarge* (oil on canvas). Art Museum, Princeton University. 11⅞ x 17 inches. Monogrammed and dated *C. H. M. 1872*. Acquired from Miss Rosamund Clark.

Fig. 27. *Schooners, Ironbound Island, Maine* (watercolor). Art Museum, Princeton University. 9⅞ x 12⅞ inches. Gift of Miss Elizabeth Moore.

Fig. 28. *Sawmill at West Boxford* (watercolor). Art Museum, Princeton University. 11⅞ x 18 inches. Gift of Miss Elizabeth Moore.

Fig. 29. *Venetian Doorway* (watercolor). Owned by Miss Elizabeth Norton, Cambridge, Mass. 12½ x 9½ inches. Signed and dated *C. H. M. Venice. 187[6?]*. From this watercolor the artist made the mezzotint illustrated in Fig. 35.

Fig. 30. *Near Simplon Village* (watercolor). Fogg Art Museum, Harvard University. 6¼ x 8⅞ inches.

Fig. 31. *Storm Clouds over Simplon Village* (watercolor). Art

Museum, Princeton University. 11¼ x 15⁷⁄₁₆ inches. Gift of Miss Elizabeth Moore. Monogrammed and dated *C. H. M. 1881*, this watercolor was thus presumably either finished or redone some four years after Moore's return from Italy.

Fig. 32. *Simplon Village* (watercolor, unfinished). Art Museum, Princeton University. 11 x 14¾ inches. Gift of Miss Elizabeth Moore.

Fig. 33. *Water Mill, Simplon Village* (watercolor, unfinished). Art Museum, Princeton University. 10¾ x 14¾ inches. Gift of Miss Elizabeth Moore.

Fig. 34. *John Ruskin* (pencil drawing). Fogg Art Museum, Harvard University. 8 x 5¾ inches.

Fig. 35. *The Old Doorway, Venice* (mezzotint). Art Museum, Princeton University. 7¼ x 5¼ inches. Gift of Miss Elizabeth Moore. See Fig. 29.

Fig. 36. *On the Lagune* (mezzotint). Art Museum, Princeton University. 7¾ x 11 inches. Gift of Miss Elizabeth Moore who owned the watercolor from which this mezzotint was made.

Charles Herbert Moore

LANDSCAPE PAINTER

CHAPTER I

Boyhood and First Steps in Painting

CHARLES HERBERT MOORE was born at 9 Carroll Place, Bleecker Street, New York City, on April 10, 1840. His father was Charles Moore, his mother Jane Maria Berendtson (a Dutch or Scandinavian name, anglicized as Benson). The Moores were of a sturdy stock, New England Puritans, early settlers in Massachusetts. An ancestor, Lieutenant Joseph Moore, of Chelmsford, Massachusetts, had served at the storming of Quebec in 1759. Moore's grandfather, Colonel Herbert Moore, played his part in the War of 1812. An ancestor on the spindle side, John Thorndyke, was one of the founders of Beverly, Massachusetts. Anticipating curiously his descendant's future enthusiasm for England and for architecture, John Thorndyke died while on a visit to his brother Herbert, who was a prebendary of Westminster Abbey, and was buried in the east cloister of England's major Gothic sanctuary. It was an ancestry that guaranteed Christian piety and an uncommon heritage of physical and mental vigor.

Moore's father kept a lace shop in New York, and transiently in San Francisco, a calling that requires taste. Moore's upbringing was deeply religious. His mother was a devout Swedenborgian, with the spiritual enthusiasm and insight proper to that sect. She awakened in her son a life-long interest in Swedenborg's theology. His father, apparently a neutral influence in Charles Moore's religious life, favored the quietism of the Quakers.

Charles Herbert Moore was the firstborn of what was to be a patriarchal family of six sisters and three brothers. Such primogeniture, especially in families of moderate means, often makes for exceptional responsibility and ability. It did so in Charles Moore's case.

Concerning the boy's education we have his own statement in *Who's Who* that he "was educated in the Public Schools of New York," which implies that his family was in moderate circumstances. Here his daughter, Miss Elizabeth Huntington Moore, his collaborator in the illustration of his famous books on architecture, contributed a reminiscence which suggests that Charles

Moore's artistic vocation announced itself promptly. At thirteen or earlier he was taking drawing lessons from Mr. Benjamin Coe, who was a private teacher, with the James boys, William and Henry.

Mr. Coe's pedagogical activities are charmingly suggested by his sometime pupil, Henry James, in *A Small Boy and Others*. As exemplars Mr. Coe produced numerous cards with his own designs. "They represented crooked cottages, feathery trees, browsing and bristling beasts; all rendered as I recall them, in little detached dashes that were like stories told in words of one syllable, or even more perhaps in short gasps of delight." Not much here to nourish the talent of Moore soon to be a disciple of Ruskin, nor yet that of William James transiently to be a protégé of William M. Hunt and John La Farge.

Before leaving this trio of uncommonly talented small boys, the obvious comment is inevitable, that only Henry James was to run a consistent course, while William James and Charles Moore, both naturally gifted as draughtsmen, were to transmute their creative into critical gifts under that powerful academic drag, which at Harvard merged personal creation into its vast sea of collective erudition. Mr. Coe is faintly known today as a genre and landscape painter born in 1789, who moved from Hartford, Connecticut, probably before 1850 and set up in New York as a teacher of drawing and painting. His professional standing must have been good, for he was an occasional exhibitor with the National Academy from 1846 on. His exhibits were of a slight sort—generally a single drawing or watercolor, probably just enough to maintain his professional standing. Henry James represents him as a chipper, perhaps inspirational, teacher. But he seems to have been also a very thorough person. In a letter dated only May 31st (but pretty surely written between 1853 and 1855), Mr. Coe writes to Moore's father: "If he [Charley] becomes exceedingly careful, he will produce works that will satisfy the expectations of his friends." Charley was to become "extremely careful" in many fields with the predicted excellent results.

Under Mr. Coe's tutelage, Moore showed an extraordinary precocity. This may be traced in letters from his mother to his father then seeking new fortunes as a merchant in California. The year is 1853. "Charley" is thirteen years old. Mr. Coe has advised him to paint a picture for the exhibition of the National

Academy. Either Charley modestly declined the ordeal, or the picture was refused, for his first exhibits with the Academy are of 1858. More astonishing yet, "Charley is regularly to paint landscapes for the New York art dealers Williams and Stevens, and Hudson and Smith." They paid two dollars a small picture whether copy or original, five dollars for a large picture, supplying the canvases. It should be recalled that a dollar was then a day's wages for a skilled artisan.

A single example of these juvenilia, a somewhat darkened damaged landscape (Fig. 2), is still in the possession of a nephew, Mr. Howard L. Moore at Putney, Stratford, Connecticut. The family tradition holds, I believe correctly, that it was a gift of the boy artist to a brother. In a letter of April 28, 1853, Moore's mother writes, "Charley is very ambitious, has a large landscape on his easel." This may very well be that "large landscape." The execution is rather heavy-handed but also most resolute. It betrays the influence of Durand's minute scrutiny of obvious appearances—no bad influence for an ambitious and gifted youngster. I am not sure whether it is a copy or an original. The big oak off center to the left, with every corrugation of the bark insisted on, is entirely in Durand's manner. One of the dealer patrons had advised "Charley" to study Cole and Durand, leading American landscapists, which is as if a French adviser of the moment should bid a novice study Corot and Rousseau. Charley, with an already remarkable lucidity, ignores the romantic Cole, and being already a Pre-Raphaelite in germ, assiduously studies the meticulous Durand. It is an early evidence of Moore's essential stoicism—of his clear perception of what concerned himself.

Our next document for Moore's progress is a business card now in the possession of his niece, Mrs. Theodore Krueger, which announces that the partners Benjamin H. Coe, Elmer E. Parmelee and Charles H. Moore offer lessons in drawing and painting at their studio in New York University. As an attraction they mention original paintings by A. B. Durand and F. E. Church, a sometime pupil of Mr. Coe's at Hartford, as models to be copied by the pupils. Since Durand was a veteran in minute realism, while Church was a new marvel in that manner, this art school was, whether deliberately or not, in sympathy with Ruskin's Pre-Raphaelite doctrines. Ruskin had already written with real if qualified admiration of Church's amazingly detailed foregrounds.

School of Drawing and Painting,

NEW YORK UNIVERSITY—ENTRANCE ON WAVERLEY PLACE.

BENJAMIN H. COE ELMER E. PARMELEE & CHARLES H. MOORE,
TEACHERS.

TERMS PER QUARTER OF TEN WEEKS,	1 Lesson per week.	2 Lessons per week.
Drawing, in Pencil, .	$5	$8
" in Crayon,	6	10
" in Pastel, (colored crayon,)	7	12
Painting Flowers, Figures or Landscape in Water Colors,	6	10
" Figures or Landscape in Oil Colors,	7	12
Course of Lessons in Perspective, .		$2

Instruction on favorable terms, by the week, month, or year, to those intending to become Artists or Teachers.

An extensive and valuable collection of Paintings by Durand, Church, and other distinguished Artists, are furnished for models, and pupils taught to make exact copies from them.

Instruction in Schools or Families as usual.

Classes in Sketching and Painting directly from Nature, in May and June.

Pencil Sketches made by pupils during the past Summer may be finished at our rooms, either in Oil or Water Colors.

For Moore, then, the association with his senior partners was a fit preparation for his later explicit loyalty to those disciples of Ruskin *in partibus*, the so-called American Pre-Raphaelites. I sincerely hope that paintings by Coe and Parmelee will turn up. They seem to have been prophetic talents. Unhappily the business card of Coe, Parmelee and Moore is not dated. But Moore, still in his 'teens, can hardly have been regarded as qualified for partnership until he had exhibited with the National Academy, or at least had had pictures accepted by its jury. Moore's earliest exhibits are of 1858, accordingly that year should be about the date we are seeking.

In 1856 Moore's father, having had no success as a shopkeeper, retired, buying a small farm at Putney, Stratford, Connecticut. He moved his big family, including eight children, from fourteen years old down, into the spacious Early Republican farmhouse. His twenty-eight acres were and are a sightly possession, sloping gently towards a bend in the Housatonic, and heavily studded by the protruding heads of imbedded small boulders. As a farm it never could have come to much, but it provided a certain amount of food, and between cultivation and housekeeping furnished occupation and a playground for the growing boys and girls.

This move left Charley, the eldest son, at sixteen, on his own in New York. It is a good guess that he continued the quantity production of small landscapes for the art dealers, and was self-

supporting or nearly so. One of these early pictures was taken to the new home in 1856, and still hangs there. It is a skillful, ambitious and promising work. Within three years Charley had become a junior partner in the art school of his master, Coe, had exhibited in 1858 with the National Academy, and sold one of his pictures to a well-known New York collector, R. L. Stuart. At eighteen then, Charley, considering his frugal needs, will have been prosperous, and probably, as a devoted eldest son, sharing his surplus with his family. Putney, Stratford in those days was a good three hours' travel from New York, an expensive journey. So Charley probably visited the farm only on such great festivals as Thanksgiving, Christmas, etc. He may there have made acquaintance with the charming river, the Housatonic, which was to supply the subjects for many of his early landscapes. We may imagine him a hard-working, self-sufficing lad, making steady, solid progress in his art, and finding sufficient companionship in his schoolmates in the high school and in Mr. Coe's art class.

What helpful pictures could an eager boy meaning to be a landscape painter himself have seen in New York in the late 1850's? The collection of the magnanimous art patron, Luman Reed, offered many Coles and early landscapes by Durand. Cole's facile romanticism offered little to help the very strenuous youngster that Moore undoubtedly was. Durand's plodding fidelity to minute appearances may easily have stimulated an ambition to do that sort of thing better.

Of course the National Academy exhibitions were visited faithfully. There the paintings of the skillful Düsseldorfian Worthington Whittredge hung beside the homemade efforts of McEntee, Cropsey and others. Kensett was probably the star exhibitor. F. E. Church may have shown that one could go far in painting details without loss of breadth.

From Mr. Thomas Jefferson Bryan's Museum of Christian Art and its score of Italian and Flemish primitives, a good eye might have learned something.

In New York, the influx of landscapes by the Barbizon painters hardly began before 1860, Charles Moore's twentieth year, but some Corots came over rather earlier. These will have been the silvery and feathery pictures which soon were to be popular. I feel sure that Charles Moore with all of the senior and better

7

American painters, Inness and Homer Martin excepted, must have disapproved Corot's apparently too facile magic.

Moore's first characteristic landscape was exhibited by the National Academy, 1859, No. 806, under the title "In Berkshire County" (Fig. 3). It was loaned by the owner, the well-known collector, R. L. Stuart, whose pictures have recently been transferred from the New York Public Library to the New-York Historical Society as a permanent loan. Three others of Moore's four exhibits were also lent by owners. He must have been prospering. The interest of this little picture lies in the foreground. Great and rewarding pains have been spent on the old, unkempt birch tree that overhangs two mossy limestone boulders, on the precise forms of foliage and flowers, on all foreground textures. There is little positive color. Middle distance, distance and sky are hazy and gray. A flight of ducks in formation is the only lively feature. The ducks and the lush growth tell that it is springtime.

Everything, I am sure, has been painted on the spot. Moore was tackling a problem which a little later was to interest La Farge—the difference between looking at a landscape through a window and observing it when out of doors yourself. It is as if Moore sought this effect, but let nature build him the window. It is a picture of a window offering a view, and he has cared too much about the window to give the view any competing or distracting definition. A nice touch in a rather sullen, overcast sky is the irregular swinging V of flying wild fowl which takes up the motives of the gently curving birch and the swaying and festooning lines of vines and shrubs in the foreground. By this perhaps superfluous analysis, I merely want to emphasize the exquisite thoughtfulness that went to the making of what might, viewed superficially, seem a rather naïve and even ordinary little picture.

More ambitious and perhaps less ingenious is the canvas owned by Mrs. F. Van R. Phelps of White Plains, N.Y. I shall give it the neutral title "River View with Cattle" (Fig. 4). One looks beyond a point where two branches of a quiet river flow together to a range of blue mountains in the distance. My guess is that the river is the Housatonic. The effect is spacious and tranquil; positive color is dimmed by the prevailing light mist. Foreground details are notably sharp and expressive. These details have been painted with a free yet precise brush, over a surface which while

wet had been completely worked over with the blender. This rather monotonous texture after all yields the atmospheric effect the young artist sought. As usual in these early Moores, the velvety reflections in the water are worked out with much finesse, while the vigorous drawing of trees and weeds in foreground and well-placed flashes of light from tree trunks and the path at the right, give vivacity to a generally unsalient composition. It is a thoughtful picture which will repay patient and thoughtful consideration. It is painted on a very light canvas, hardly better than a cotton drill, and has crackled heavily because of some dryer in the vehicle. It is signed, lower right, "C.H.M." It may be National Academy 1859, No. 309, "Early Evening on the Housatonic," owner Edwin Thorne.

A Currier and Ives lithograph dated 1867, and entitled "View on the Housatonic," seems to me a copy of a Moore painted before 1860. A comparison of our reproduction (Fig. 5) with that of Mrs. Phelps's picture (Fig. 4) seems to me to show the same general region with a notable similarity in handling. There probably was no signature on the original painting, or the lithographer would have copied it. This again suggests an early date when Moore was at times negligent about signing his canvases. As compared with the Phelps picture, the lithograph is more spacious and clear in composition. The details are more various and interesting. The foreground is more minutely studied. In both pictures the cloudless sky is rather monotonous. The lithograph enlivens the sky with a few birds. Moore or his lithographer must have taken great pains with the job, for the colored inks are true to Moore's sober and thoughtful scale. There is nothing of the garishness of the standard Currier and Ives landscapes. All these considerations combine to convince me that the missing oil painting was painted in 1859, as a sort of improvement on Mrs. Phelps's picture, and as an anticipation of the still better "The Catskills in Spring," dated 1861, at Vassar College (Fig. 9).

These two pictures, painted by Moore when he was only about nineteen, are amazingly mature. He is meticulous in foreground details, but the effect is not small. The careful, minute strokes and touches keep a paradoxical breadth. The gifted youngster is also sensitively studying atmospheric effects in reduced light. Here is an intelligence that should take the young painter far beyond his probable exemplars, Durand and F. E. Church.

CHAPTER II

Paintings of the Early 1860's

AT EIGHTEEN Charley Moore had set up as a professional land-scape painter, and as junior partner in Mr. Coe's respected art school. Before Moore reached twenty-two, we know that he had sold eight of his landscapes, probably more. Four had been bought by the wealthy philanthropist, Matthew Vassar, and were soon to be exhibited in the college that bears his name. When we recall Moore's juvenile quantity-production for the downtown dealers, it is clear that he evinced a precocity almost unprecedented in the annals of American painting. In his early twenties he was com-pletely on his own, and since his personal habits were frugal and his disposition generous, he must have been saving money, and sharing his prosperity with the big and never prosperous family at Putney, Stratford.

But this early success did nothing to spoil him, as a survey of the pictures he painted in the earliest eighteen-sixties will show. Scorning a facile success which would have allured a weaker char-acter, he was simply merciless in exacting the best from himself. This strenuous endeavor was soon to be brought to focus in his devotion to the Pre-Raphaelite faith of which John Ruskin was the apostle. I am sure that a discriminating English or European critic who had seen Moore's pictures of the early 1860's would probably have declared him our best American landscapist, and certainly would have thought him the most promising of the younger American painters, among whom were George Inness, Homer D. Martin, John La Farge and Winslow Homer.

The most colorful, I think the most beautiful, landscape Moore ever painted is the tiny canvas in the New York State Museum at Albany, dated 1861. I have given it arbitrarily the title "Cats-kill Bywater" (Fig. 6). The time is late evening. The mountain range is drenched in a violet afterglow, the sky heavily flecked with rosy clouds. These tones are reflected in the quiet water. Interlocking ridges give a sense of the zigzag flow of the stream from the mountains. A curious cave, roofed by arched strata, at the left, relieves what could have been a monotonous arrangement.

Edges and textures are of the finest. The scene is spacious. Moore's watercolors of fifteen years later are more positively brilliant, have more colors, but the colors are used descriptively, quite objectively, and these admirable sheets lack that impregnation with mood which distinguishes the little masterpiece at Albany. I do not know of any American landscape of so early a date that expresses, while depicting an actual scene, so much poetical feeling in so painterlike a way. It is initialed and dated 1861, Moore's twenty-first year. He had by now come of age artistically. His succeeding Pre-Raphaelite episode was to involve a heavy sacrifice of hard-won quality.

In February of 1862 Moore wrote to a new friend, Thomas Cole, son of the famous landscape painter, describing the impressiveness of the new buildings for Vassar College, then under construction. He adds that he himself expects "to be installed" there. Clearly he had been offered a position on the Vassar faculty, and had virtually accepted it. Like so many of Moore's plans, nothing came of the negotiation. Perhaps it is enough to say that, had Moore accepted this post, Vassar would have beaten Harvard by over ten years in introducing the so-called "laboratory method" of teaching the appreciation of art, for Moore was undoubtedly versed in Ruskin's *Elements of Drawing*, which had appeared in 1857. Here is the first of those interesting "if stories" in which Moore's varied career abounded.

Why he didn't sign up with Vassar we may merely guess. Probably he was prospering so well as a professional painter that he was reluctant to tie himself down to an academic schedule. The catalogues of the National Academy from 1858 to 1869 show four pictures lent by private owners. Matthew Vassar had bought the four landscapes still owned by Vassar College—the lists may overlap a little. Probably Moore had even made savings from his partnership with Mr. Coe. It seems to have been a case of letting well enough alone, and surely Matthew Vassar must have been a far less persuasive patron and adviser than Charles Eliot Norton was to be ten years later.

In a professional career as a painter which lasted only a little more than twenty years, from 1858 to 1878 or a bit later, chronology may seem of minor importance—fortunately so, for Moore rarely signed and still more rarely dated his early pictures. However, we have a reasonable starting point for the stylistic analysis

of the early Moores in the four landscapes which Matthew Vassar gave in 1864 to the new women's college which he was founding and christening. They make the Art Gallery of Vassar College the only place where Moore's early landscapes in oils can really be studied.

The most notable of the Vassar Moores is "The Upper Palisades" (Fig. 7). A little canvas, only 12 by 20 inches, it is singularly large in feeling. In the lower lefthand corner is a faintly indicated "1860" and, evidently later and overemphatic, the initials "C.H.M." For a youngster of twenty it is an extraordinary picture. The theme is the contrast between the permanent and evanescent character of natural appearances. A basaltic cliff at the left rises powerfully, bears down weightily, and with its sloping talus drives like a gigantic ploughshare into a world that is all water, surface mist, and murky air. The thrust to the right is skillfully met and checked by the vertical sail of a river sloop and by its reflection, which also emphasizes the massive scale of the basalt monolith. This simple device as well brings a heavy imbalance into pictorial equilibrium. The water horizon to the right is lost in a sullen surface mist, above which rises the faint blink of the upper part of three sails. Above them is a dog-day mist thickening in the distance, where the faraway shoreline is dimly discerned. A general monotony of tone and handling is most skillfully enlivened and varied by the play of light, positive and constructive on the cliff, vague and mysterious on its talus and curving strand, even more evanescent up the river. Most definite, on the contrary, are the indications of the deep reflections of the headland, the sharp thrusts and swirls of the reflected light near the slope and in the wake of the heavy rowboat, whose sharply bent gunwales bracket and check the downward diagonal thrust of the cliff. Very happy is the brightening of the higher sky above the jutting headland, as emphasizing its upward thrust.

It would be easy to carry this analysis further, but it might also be tedious, and perhaps enough has been written to suggest a thoughtfulness at once robust and delicate in the young painter, who, while following devoutly his actual observation, doubtless also indulged those instinctive compositional revisions and discreet transformations which are the mark of the good designer.

To find contemporary analogies for this sullen little masterpiece, in a sort of enriched gray-brown monochrome, one has to

go far afield. The general monumental effect in a measure recalls Cotman, whose art Moore could hardly have known. The concern with muted atmospheric effects was already active in young Jimmy Whistler in England, in John La Farge at Newport, as it was in Jongkind, and in Boudin in France. In short, judging from this single canvas, Moore might be regarded as a moderate anticipator of the Impressionism, or better the Luminism, of the 1870's, though his course, under the influence of John Ruskin, was to lead elsewhere.

The larger undated canvas, "Down the Hudson to West Point," 20¼ by 30¼ inches, at Vassar, repeats the dynamic quality of "The Upper Palisades." Its compositional gravity is obvious in the reproduction (Fig. 8). The precise and specific character of the foreground details suggests that at the time of its painting Moore may already have been following the precept of Ruskin's *Modern Painters*. But of course Church or Durand may in this matter have been his exemplars. Very much his own is the dynamic pattern of the clouds and their accurate placing in distance. These two pictures have so much in common in general feeling and in almost colorless tonality that it is safe to assume they were painted at about the same time, in 1860. Indeed, from the sense of sweltering mist it seems probable that they were painted in midsummer or later. They are both notable expressions of a somber mood.

Quite different in mood is "The Catskills in Spring," signed and dated 1861 (Fig. 9), but its blitheness is still of an elegiac character. The essential theme, the contrast between the transient and permanent in nature, is the same, but it is treated with greater breadth and on a greatly expanded scale. The unmodulated blue of the mountain mass becomes a symbol of its permanency, a something unmovable, as compared with the foothills which, though seeking stability, are modified by erosion and veiled by all sorts of growth; in sharper comparison with the clouds which are massed and driven by the winds only to be frayed out in moving and luminous filaments. The general arrangement, a singularly happy one, is in easy zigzags or echelons which have dynamic value and assert the scale and, implicitly, the movement of the lowland towards the mountains. Very essential is the mountain in remote middle distance to the right, which emphasizes the distance between the edge of the lowland and the faraway moun-

13

tains. This edge is made important by receiving the shadow from the beautiful poised cloud diagonally above.

The indications of tender foliage in foreground and nearer middle distance are delicate, but always precise, nothing blurred or blended out, no meaningless touch. Much here reminds me of early John Constable, whose painting Moore can hardly have seen. We have to do in any case with a similar probity of observation and immediacy of execution.

It would be easy to dwell on minor felicities of composition, such as the post and rail fence which affords a sort of elastic support and source of this general zigzag arrangement. How much of this sort of thing rests simply on observation and a carefully chosen point of view, how much on the usual unconscious omissions and transpositions, it is impossible to tell. The most devout worshiper of natural appearances inevitably helps appearances out, and usually without any idea that he is doing so.

The last of the four pictures at Vassar, "Morning over New York" (Fig. 10), is a very long canvas, 12 by 30 inches, and remarkable chiefly for its spaciousness and its exquisite registration of infinitesimals of pellucid tints. The upward swirl of smoke continued by clouds gives a subdued joyousness to what is on the whole a pensive work. Of American painters of the moment, I can imagine only Kensett and Whistler undertaking such a theme. Kensett would have carried it off briskly and more obviously; Whistler, disliking the dark and bristling foreground, would have forced it all into more limited and harmonious tonalities. It cannot be far in date from the three other canvases of the Vassar group—perhaps in 1859 or 1860.

If we compare the landscapes that I have described with what was being painted in America in the early 1860's it is hard to find their equal in quality and in promise. Kensett, a facile executant, was painting similar themes with greater assurance, but perhaps he hesitated too little. Inness had done nothing as good, as sensitively and largely seen. Homer D. Martin had already shown his rare gift for larger composition, but had attained no comparable skill in handling and harmonizing details. In short, if I were to emulate Mr. Winston Churchill in writing an "if story," the title would be "If Charles Herbert Moore Had Not Ceased Painting Landscapes," and the substance would be that if Moore, who lived to ninety, instead of building a dozen years or

so on the foundation of these few early landscapes, had built for thirty years, he might have made himself the best American landscape painter of his generation. But this was not to be.

It may be well to complete our review of these early pictures by asking what preparations were made for them. The answer seems to be found in a considerable group of sketches by Thomas Cole made in the 1830's, and a similar group by Homer D. Martin made in the late 1860's and early 1870's, which we have at Princeton. Since the procedure is identical in the two groups, separated in time by a matter of forty years, it is a safe inference that they represent the standard sketching habits of the Hudson River School.

The paper, usually detached from sketch books, is invariably tinted, generally gray or pale brown. The essential contours are drawn with a rather hard pencil. Light effects are obtained by brushing in patches of Chinese white. The view is always carefully chosen, is a composition rather than a casual study. Such sketch books were a repertory of landscape motives that could be elaborated into pictures in the studio.

The only sketch of that sort by Moore, so far as I know, is a little sheet which was at Princeton but is now apparently lost. It is initialed "C.H.M." and bears his pencil notations "Near Great Barrington, Mass. Looking North. Autumn." Another hand has written in "Charles H. Moore." The domical mountain against the sky is of course Greylock with its buttressing ridges. There is much more in this modest sketch than at first meets the eye. The pencil indications are of extraordinary variety and expressiveness. Differences of pressure, I think also of speed, are everywhere evident. Everything is perfectly placed and paradoxically large in feeling. The whites that flick the nearby knolls lead up systematically and delicately to the marbled sky. Their direction, northeasterly, tells that it is late afternoon, the sun being low and westerly. There is great refinement, and withal plenty of strength, in the apparently simple handling, a surprising work for an eighteen-year-old boy. For the probable date of this drawing is 1858, when we know that Moore was painting in the Berkshires. One is tempted to associate it with his Academy Exhibit of 1859, No. 418, "Autumn in the Mountains," but since the picture has disappeared, this is merely a surmise.

15

CHAPTER III

With the American Pre-Raphaelites

IN THE EXHIBITIONS of the National Academy for 1858, 1859, and 1860 Moore had shown six landscapes of which three were listed as sold. Between 1861 and 1865, inclusive, he showed nothing with the Academy, though in this period he sold the four landscapes to Matthew Vassar. He was doing pretty well without academic benefit.

In the catalogue for 1862 C. H. Moore appears in the list of A.N.A.'s (Associates of the National Academy), but never again. Since the Academy records for that year have been destroyed, what actually happened is obscure. However, it is probable that Moore either failed to qualify for or relinquished a generally coveted honor as a protest against the Academy, and as an expression of his incipient Pre-Raphaelite convictions. If so, it was a gallant gesture for a youngster of twenty-two, with his way to make.

In 1865 Moore again exhibited with the National Academy, and also in 1867 and 1870. Meanwhile he had married and the Pre-Raphaelite junta had disbanded. No question of loyalty was now involved in resuming relation with the Academy, which after all sold half the pictures Moore exhibited between 1865 and 1870. Thereafter Moore had virtually ceased to be a professional painter, and was directed towards a new academic career at Harvard.

Between 1861 and 1871 his correspondence and the exhibition catalogues tell us that he painted a number of pictures in oils, certainly no less than fifteen. Of this group it has been possible to locate just four landscapes. Only one of them, "Leeds Bridge" (Fig. 12), is really important. His marriage, in 1865, and the birth of his daughter were distractions, of however delightful a sort. His move to Catskill, N.Y., and house hunting there taxed his energies. Finally in 1866 and 1867 etching and plans for etching seriously competed with his regular vocation as a painter.

Moreover, Moore's enthusiastic association with the American Pre-Raphaelites, while it did much to develop him, may easily

have diminished his output. There were new attitudes to be pondered, new and more laborious methods to be mastered, new friendships to be cultivated, new literary activities to be undertaken. A young man of Moore's gravity suffers heavily the growing pains incident to any conversion.

It is probable that in his late 'teens Charley Moore had read something of Ruskin, if only in the generous excerpts from *Modern Painters* printed in W. J. Stillman's *Crayon*, and from Ruskin's widely quoted praise of F. E. Church's landscapes. But his indoctrination with Pre-Raphaelitism seems to have been gradual, and to have become conscious and complete only when he was approaching twenty-four in 1863.

Meanwhile Moore's first meeting with an actual Pre-Raphaelite in the flesh was with the young English painter and etcher, Thomas Farrer. In 1860 Farrer came to New York, and soon handsomely proved his new loyalty by enlisting in the Union Army. Concerning Farrer, Moore wrote to his sister Lucy, on November 30, 1862. He is "the greatest gentleman friend I have in the world. . . . We have delightful talks."* What they talked about was Ruskin and his Pre-Raphaelite ideals, for Thomas Farrer, who during some dozen years was to make a good career in America as a painter and etcher, had been a personal disciple and protégé of Ruskin. In 1863 Thomas Farrer's younger brother, Henry, who was likewise a painter and etcher, also came to this country and became Moore's good friend. However, Moore's approaching induction into Ruskinism was to come under more formal auspices than that of the Farrer brothers.

So much had Ruskinism been in the air—such minute realists as Durand, F. E. Church, and Cropsey may well be regarded as naïve Ruskinians *sans le savoir*—that the emergence of an organized group of militant Ruskinians in 1863 may seem merely a culmination, and overdue.

On January 27, a small group of eager young men met at 32

* EDITOR'S NOTE: Because the first name of the Farrer referred to in this letter is not given, there seems to be some confusion as to whether Thomas Farrer or his brother Henry (see below) became Moore's "greatest gentleman friend" at this time. Frank Mather took Henry Farrer to be the one mentioned, but David H. Dickason has come to the conclusion that the date makes it necessary for Thomas to be the brother in question, and Mather's text has been revised accordingly.

Waverly Place, New York, and voted the following manifesto which was later to be published in *The New Path*, No. 1:

"We hold that the primary object of art is to observe and record truth, whether of the visible universe or of emotion. All great art results from an earnest love of the beauty and perfection of God's creation, and is the attempt to tell the truth about it."

Since sound doctrine must be promulgated, they organized under the title of "The Society for the Advancement of Truth in Art." These truth-seekers held meetings, read papers and within five months, in May 1863, issued the first number of a little monthly magazine called:

THE NEW PATH

Published by the Society for the Advancement of Truth in Art.

The New Path, as a reformer's mouthpiece, spoke out emphatically. The initial editorial declared flatly: "After forty years' uninterrupted labor they [the American artists] have not given a single work which we care to keep." Pretty sweeping for forty years that saw the best portraits of Stuart, Malbone, Morse, Sully and Neagle, not to mention the best landscapes of Allston, Cole and Durand. But moderation has never been a reformer's virtue, and in the present case immoderation reached far. I have had the pleasure of reading *The New Path*, at the Harvard Library, in a copy owned by possibly its most famous subscriber. The pages are cautiously marked for rereading by the hand of the donor, Longfellow—no radical surely, but urbanely willing to give rebellious youth a hearing.

My concern with *The New Path* is naturally limited by my immediate subject. C. H. Moore, who was only an occasional contributor. In the two years of its short life, there never was a titular editor, any more than there was ever published a roster of officers for the Society for the Advancement of Truth in Art, but the internal evidence is strong that the editorial spade-work for the struggling magazine fell upon two remarkable members, both a little senior in the group, Clarence Cook and Russell Sturgis, Jr. Years afterward, Mrs. Cook was to refer to her late husband as "the first editor of *The New Path*." But before treading *The New Path* further, a word on the men for whom it spoke.

18

The senior, apparently a dormant or as it were honorary member, was John William Hill, born in England in 1812, the second of three generations of Hills who made their mark as engravers in America. He was then fifty-one years old—a truly venerable age in the group—when *The New Path* first appeared. The reading of Ruskin had converted him from a facile and popular British manner to strenuous search for complete truthfulness.

Clarence Cook was born in 1828, trained somewhat in architecture, and passed on into critical journalism. I fancy the future investigator of the exhibition notices in *The New Path* will find a strong family resemblance between them and those which Clarence Cook, a denunciatory and dreaded art critic, was contributing to the *New York Tribune* from 1853 on. Cook was thirty-five years old when he began his apostolate.

Russell Sturgis was born in 1836, of a famous Boston clan of merchant shippers. College-trained and traveled, with encyclopaedic knowledge and a prodigious capacity for work, we may reasonably credit to him all articles on architecture, especially the long historical surveys, except those which are initialed "W" by Sturgis' partner in architecture, P. B. Wight. Sturgis was entering on a long and distinguished career as an art historian and critic of encyclopaedic sort.

P. B. Wight, born in 1838, may be regarded as mediating between the oldsters and youngsters of the group. In 1863, at the age of twenty-five, he won the competition for the new home of the National Academy, and designed it as faithfully as possible out of his reading of *Stones of Venice*. Fifty years after its demolition, I retain vague memories of its quaint impressiveness and singularity, in the architectural jumble that New York then was.

John Henry Hill, son of John W., born in 1839, was twenty-four years old, and may be regarded as the eldest of the youngsters. He had early been indoctrinated in Ruskin, was rapidly developing as an excellent landscape painter and etcher. He maintained almost to our own times the studio above Nyack, which had been his father's and grandfather's. Next to Moore he seems to me the best artist of the group, and undeserving of the neglect he has suffered from historians of our American art.

Of Moore at this point I need only note that he was twenty-

three, and had already achieved a modest success as a landscape painter, before he helped blaze out *The New Path* in 1863.

Thomas C. Farrer, born in England in 1838, was the most important of the younger members. As a personal pupil of Ruskin, he had received the laying on of hands for his fellow disciples. He painted, drew, and soon etched with a minute fidelity that must have seemed highly exemplary. We have already noted that he came to New York in 1860, three years before his younger brother Henry, who though doubtless closely associated with the group, does not appear as a member. Henry developed rapidly along his brother's lines, and after Thomas returned to England, in 1872, gained repute and popularity on his own account as an American painter and etcher.

The New Path had the sore disadvantage for an art magazine of lacking illustrations. It was in the unhappy position of vigorously praising the work of its contributors without proving the case visually. To make this defect good, an album of large photographs of drawings by the members was offered for subscription. As advertised, the title was *Photographs of Studies from Nature*, the price was six dollars for the set of ten photographs, the outlet, Brentano's, 708 Broadway. It has become one of the rarest items of Americana. I have never seen a copy. Possibly, owing to lack of enough subscribers, it was not actually published. Charles Moore's contribution was two drawings, "Cedar Tree," and "A Mandrake."

The New Path suffered the usual vicissitudes of little magazines dedicated to revolutionary reform. It early dropped the "Society" from its subtitle, but remained devoted to the "Advancement of Truth in Art." Then it went on its own without a slogan. The publication was somewhat irregular and interrupted. There was the usual appeal for financial support—unsuccessful, for the little monthly died after two years of gallant existence.

With equal energy *The New Path* dealt blows to its foes and accolades to its friends. Among artists heartily blamed were Raphael, Allston, Cole, Durand, Bierstadt, Leutze, Huntington, J. G. Brown, W. M. Hunt, W. H. Beard, George Inness, Homer D. Martin, and the popular sculptors E. D. Palmer, Harriet Hosmer, and Hiram Powers. In short, few of those artists then esteemed for accomplishment or promise escaped castigation.

Chosen for praise, sometimes qualified, were European con-

temporaries, Gérôme, Tissot, and Willems. Among veteran Americans only F. E. Church got favorable notice, and that with serious reservations. Eastman Johnson and Winslow Homer were constantly approved—a verdict which posterity has confirmed. Arthur Parton and W. J. Hennessey, among beginners, were favorably mentioned. The very popular Kensett was left without infamy and without praise. His very clear-cut practice seems to have given him a sort of immunity. Naturally the four painter members of the group were eulogized constantly and with conviction, and here on the whole Charles Herbert Moore was regarded as the "white hope" of American Pre-Raphaelitism.

Very odd is the complete ignoring of the emerging Barbizon painters. But the Millets, Corots and Rousseaus, though already visible in Boston owing to the championship of W. M. Hunt, had hardly reached New York. So we are denied the shock of reading what *The New Path* would have written, say, about Millet's "Carrying the Calf," a flower piece by Diaz, or an ultra-feathery Corot.

Moore's most important contribution to *The New Path* was a signed article, in the number for October 1863, entitled "Fallacies of the Present School." It is redolent of the Swedenborgian piety in which he had been bred. He clears the way by confuting the unfavorable estimate of the English Pre-Raphaelite Brotherhood expressed by the collector and critic James Jackson Jarves in his recently published *Art Studies* (1861).

Otherwise Moore's polemic is in pretty general terms, which may be represented by a handful of quotations. He makes useful reservations: "Naturalism [a very ambiguous term too much favored by *The New Path*] is not all we believe in, but we know it must come first." Here the term means fidelity to smaller appearances.

Then a brief credo: "The Modern Pre-Raphaelites . . . are believers in God and His creatures, and love art only as a means of expressing to others their delight." The Hudson River School would have had no quarrel with this. Moore's condemnation of the art of the recent past is sweeping: "The world has had enough morbid fiction, it now needs healthy fact. God's truth must come in and take the place of vanity." Again there is some abuse of general terms. There was some sense in taking to task the art of

the 1820's to 1860's for dealing in fictions and vanities, but it emphatically wasn't morbid, in any proper sense of the term.

A tribute to the prophet and liberator was inevitable and heartfelt. "By the mercy of God, Ruskin has been sent to open our eyes and loose the seals of darkness." A certain naïveté in this manifesto evokes the old sigh, *"Si jeunesse savait,"* and also a certain joy in the fact that youth is almost never too knowing. As a gallant youth movement, the Society for the Advancement of Truth in Art ran singularly true to form.

Moore's only other signed article in *The New Path* (ii, 134) was a defense of one of his pictures against unfair criticism in the *New York Evening Post*. Moore's modest defense is converted into a rather vicious counterattack on the critic, who, it appears, was an unsuccessful and disgruntled painter. About all that survives of present value from these battles long ago is the assertion that at twenty-five Moore was finding a good sale for his landscapes, and already wielded a vigorous pen.

CHAPTER IV

Marriage. Move to Catskill.
His Activities Described for
Charles Eliot Norton

IN 1858, AT EIGHTEEN, Moore set up as a professional painter, giving his address in the catalogue of the National Academy as New York University. In 1859 and 1860 he was in the new Studio Building, at 15 West 10th Street. Here there is a gap of some four years during which he did not exhibit, but he was presumably at the Studio Building until 1865, when he gives his address as Catskill, N.Y. Meanwhile, on July 19, 1865, Moore had married Mary Jane Tomlinson. The quiet wedding took place at Schenectady; and Bishop Potter, a cousin of the bride, officiated. The move from the relative ruralism of Greenwich Village in the 1860's to the real country may have been motivated by his marriage and by the prompt appearance of the baby daughter, Elizabeth Huntington. I like to think, though it is a mere surmise, that he chose Catskill in order to be near the studio and the family of the pioneer American landscapist, Thomas Cole.

In any case he settled for a few years after 1865 in the charming battened and raftered "Lodge," designed by himself, which still stands high on the river terrace, facing to the east over the tops of old trees the Taconic range, and to the west, the nobler undulations of the Catskills. Half a mile down the hill to the south was the Thomas Cole estate, a fine Early Republican mansion and several studios. It was occupied by Cole's children who became Moore's friends. It is still in the hands of a descendant of Cole, and should be visited by the intelligent tourist when he passes nearby in crossing over the Rip van Winkle Bridge.

Naturally Charles Eliot Norton, substantial rentier, distinguished private scholar, and man of letters, close friend of Ruskin and patron of the English Pre-Raphaelites, must early have known and approved the activities of his young fellow Ruskinians banded in the Society for the Advancement of Truth in Art. Moore visited Norton at Ashfield, Massachusetts, Norton's new

summer home, probably in the summer of 1865, when Moore was painting in the Berkshires, just across the Hoosac Mountain. A letter to Norton, dated March 11, 1867, apologizes for not returning Rossetti's "Before the Battle," which Norton had lent for copying. The delay has been caused by trouble in finishing a picture for exhibition, probably the "Hudson River above Catskill," No. 522 in the 1867 exhibition of the National Academy. The middle distance and distance have come well, but the objects in foreground are badly related, do not "help each other." The observation is valuable as showing that Moore's Ruskinian "truthfulness" did not prevent him from exercising normal freedom in composition.

The gaining of Norton's interest and friendship was a turning point in Moore's career. It was to result in our losing perhaps the most promising young American landscape painter of the 1860's in order that Harvard might gain a distinguished professor and critic of architecture.

Moore's activities and ideals in his early Pre-Raphaelite phase are the burden of two letters written to his new friend and mentor, Charles Eliot Norton, in February and April of 1866. I use this material through the courtesy of the New York State Museum.

"My principle [sic] winter work is a view of the mountains and the valley in snow (Fig. 11). . . .* The peculiar structure of these hills is very marked in Winter, & their sculpture brought out in most ineffably subtle light and shade. . . . The color of the shaded parts in clear mornings is purest blue & in the lights the soft, redish [sic] purple of the bare trees coming up through the snow is most lovely. . . . In the middleground I have part of the village— ugly white houses &c—but I do not think they are altogether ugly associated as they are with the rest of the subject and drawn in various perspective and light and shade—It is quite wonderful how the 'play of the light of heaven,' makes many ugly things interesting. In the foreground are some naked willows, & the color of these in the sunlight is very beautiful, & especially so in contrast with the prevailing blue of the subject. This picture is quite small (7 x 10 inches). I could not make it larger without risk of being unable to finish it while the snow lasts."

* EDITOR'S NOTE: This charming little oil painting, now in the Art Museum, Princeton University, was acquired by Frank Jewett Mather, Jr., after he had ended his work on the manuscript for this book.

Moore seems to have been the first American painter, indeed one of the first painters anywhere, to see that snow is blued by the sky. Thus he anticipated the vision of a Twachtman by a full generation. Of course there were occasional paintings of snow scenes in the sixties, by Mignot, Durrie, and the designers for the Currier and Ives lithographs, but these artists did not take the pains to look at snow: they had it ready made in their tube of Chinese white. Incidentally, it is worth noting here that any convinced Pre-Raphaelite painted much from memory.

In the same letter Moore describes a larger landscape. "Last Summer I made a beginning upon a subject that has particularly interested me for a long time. It is a view of the valley from a neighboring hill & embraces a wide extent of country. I think the composition of the landscape from this point is the most graceful & perfect of any that I have ever seen. I am painting it much larger than anything I've done before—(15 x 24 inches.) The mountains are about ten miles distant, and are seen [as] infinitely lovely breadth of undulating country mostly cultivated but broken with passages of woodland. The Catskill creek forms a central and conspicuous feature. I hope to get it completed during next summer." The scene is given in a pen drawing for an etching, "The Valley of the Catskill from Jefferson Hill" (Fig. 13), signed and dated 1869.

Still another picture—"Last October I got a colored sketch of a snow squall partly veiling one of the principle [*sic*] mountains and showing a bow of prismatic colors. I intend to make careful studies of the place or as soon as I get opportunity, & endeavor to paint this effect from memory." This "colored sketch" may have been the amazing little watercolor (Fig. 14) which Miss Moore has given us at Princeton, or a similar sketch. In any case our watercolor, whether for precision in drawing or brilliant truthfulness of color, remains one of the finest aquarelles ever painted in a country that has bred a Winslow Homer and a John Marin.

What must have been Moore's most Turneresque effort seems to be represented by Number 7 in the Academy exhibition of 1867, entitled "October Snow Squall," and by a later echo in a tiny etching dated 1869 (Fig. 18).

Other projects are mentioned. "I am anxious particularly to do some of the fine gorges and torrent passages in the mountains—

the Kaaterskill Falls in ice is a pet subject of mine for the future. Also the great outlook upon the Valley of the Hudson from the top of the mountains." So far as I know these plans were not carried out.

Another letter to Norton tells so much of Moore's ideals at twenty-six that it must be quoted in full.

<div style="text-align: right">Catskill-on-Hudson
April 8, 1866</div>

My dear Mr. Norton:

Your very interesting letter of March 26 came while I was away.

Your remarks about my work are very gratifying to me. I love it, my work, very much; delighting beyond expression in the beauty of nature. I believe I am moved as deeply by all conditions of natural aspect as it is possible for a human soul to be moved by the Creator's work; but how far my work is likely to develop into anything of a "higher order" is a matter upon which I try to give myself little concern.

Plain faithful recording is infinitely delightful to me & I think it possible that I may never do anything else. I think it is worthwhile "to spend a life" in doing this, especially when popular art is in such condition as at present.

I often feel deeply, however, the wide difference between this and anything really GREAT.

If my work does anything towards promoting a more universal and true love for nature, it will be the most I hope from it. It will be for the future to build higher, but at present, I think, we need wide and deep foundations of "Realism"—at least I am fully persuaded of the truth of what Mr. Ruskin says in his pamphlet on Pre-Raphaelitism, namely that "whatever greatness any among us may be capable of, will, at least, be best attained by beginning in all quietness & hopefulness to use whatever powers we may possess to represent the things around us as we see and feel them; trusting to the close of life to give the perfect crown to the course of its labors, & knowing assuredly that the determination of the degree in which watchfulness is to be exalted into invention, rests with a higher will than our own."

I shall try to do something during the summer that I can offer you.

I have just finished my little winter study & should be pleased if you would see it.*

Mrs. Moore was much gratified by remembrances from yourself and Mrs. Norton & we cordially return the same.

<div align="center">

Very truly yours,

C. H. Moore

</div>

He continues. "There is a fine old stone bridge which I think I must draw. It is something like this [sketch of a five-arched bridge] the main arch spanning the channel. It is quite what Mr. Ruskin calls the 'ideal of bridge.'" This later appears in "Leeds Bridge" (Fig. 12), now at Princeton but formerly in the collection of the late Mrs. Juliana Force, and also in an elaborate drawing made in 1869 for an etching (Fig. 15). What is interesting in this letter is the copiousness of Moore's imagination: early in 1866 he had many more ideas for pictures than he could execute in the three following years.

The newly wed Moores were apparently living temporarily in Catskill Village, for Moore writes, "We expect to occupy a pleasant little cottage in the Spring." This was apparently the nucleus of "The Lodge."

There had been a moment when the young bridegroom, faced by the uncertainties of an artist's earnings, had proposed to Norton setting up a drawing class in Cambridge. The letter therefore closes: "At the time I wrote you about a class in drawing I had serious thought of coming to Cambridge, but it finally seems best for me to remain here. I now feel quite permanently settled."

As it was to turn out, the Cambridge adventure was being postponed only for a matter of five years.

* EDITOR'S NOTE: This seems to refer to Fig. 11, "Winter Landscape, Valley of the Catskill."

CHAPTER V

Moore's Pre-Raphaelite Paintings, Drawings and Etchings

In his letters to Norton, Moore mentions four landscapes in progress. In the exhibitions of the National Academy for 1865, 1867 and 1870 he showed six pictures, four of them sold. Evidently he was productive and reasonably prosperous. But most of those pictures have gone astray. To represent him in his fully Pre-Raphaelite phase, extending about ten years, we have only four oil paintings, a handful of drawings and etchings, and a few preparations for etchings. That versatility which was ultimately going to kill the painter in him is beginning to manifest itself. Happily, enough of his work in various mediums remains to tell us what we need to know about Moore's most strenuous years as a landscape painter.

The characteristics of Moore's developed Pre-Raphaelite style are strongly hinted at in a *New Path* notice of "A Winter Study in the Catskills," National Academy exhibition, 1865, No. 60. The critic must have been Clarence Cook, and like all art critics he suffered in the hopeless struggle to make a reader see a picture through the ears. How well I know myself the fascination and futility of that endeavor. The critic, in *The New Path*, ɪ, 193, praises "the perfect union of detail with general effect," and makes his general estimate as follows: "In this 'Winter Study' there is more accurate perception and faithful rendering of all the facts of nature taken together, near and far, small and great, distinct and vague, local and general, than in any landscape picture of the past year by any American artist, so far as we know and have seen." In the absence of the picture itself this may serve as a general if vague covering eulogy for the handful of works in Moore's definitive style which we are about to consider.

Perhaps the earliest of Moore's Pre-Raphaelite landscapes is the little oil sketch at Princeton which we may call "Upland Pasture" (Fig. 1). Though the handling is slight, the eroded sculpture of the rolling pasture is sufficiently expressed. It is

early autumn, for the grassy hillside is parched to a pale brown, and there is an effective flash of scarlet in the maple grove at the left. On the back of the canvas was originally written, "Charles H. Moore, Caaterskill, N.Y." Moore and his bride were certainly settled at Catskill early in 1866, and probably came there in the autumn of 1865. So the little sketch is probably to be dated in the early autumn of 1865. This is the sketch that I bought at the Thomas Cole Studios, and it probably was a propitiatory gift to Cole's children, old acquaintances but new neighbors.

At this point should be recalled the amazing little watercolor, "Snow Squall" (Fig. 14), which we have already considered in connection with a letter of Moore's to Norton. Its date should be somewhere in the winter of 1865-1866.

"Leeds Bridge" (Fig. 12) is so thoroughly characteristic of Moore's developed Pre-Raphaelite manner that it needs a rather elaborate analysis. The little canvas, 11 by 16 inches, is signed with the monogram "C.H.M." and dated 1868. For its precise and beautiful composition in complementary and tangential curves—very active curves—it is immediately impressive, and perhaps not quite agreeable. The handling is at high and uniform tension. The hand seems never to have relaxed or rested. The skin of the earth seems stretched a little too taut. It is an effect one finds in the contemporary landscapes of Holman Hunt, a defect, if it be that, which oddly is never felt in the minutely studied landscapes of the Italian and Northern primitives, possibly because, taking truthfulness for granted, they made no doctrinal assertion of that virtue.

The tension of this picture's surface is so extreme that it makes distant groves look as if they were sculptured, and even the very light clouds radiate powerfully—incidentally carrying through the general system of opposing and reinforcing curves—as if from an explosion below the sky line. To repeat, this austerity is not wholly ingratiating, but it is very personal and distinguished. It means an unusual concentration of eye and hand, a concentration that is as sensitive as it is intelligent and precise. These distinguished qualities are in a sense imposed on the scene by the artist. An ordinary mind and eye would have felt, would have seen nothing austere in this pleasant bit of rural scenery.

The handsome, five-arched stone bridge in right middle distance, is that "perfect bridge" which a couple of years earlier

Moore had described to Norton. Moore plainly did much thinking before he exploited his happier discoveries. Miss Moore owned two line drawings of this composition: one of them was probably a preliminary sketch, the other, made later, was for an etching (Fig. 15).

The reader must study for himself in the illustration (Fig. 12) the complex and really urbane perfection of Moore's composition. Middle distance and distance have something fairly Poussinesque about them in gravity and in impeccable balance. Slight dissonances—valuable as contrasting notes—in the bristling shrubs, trees, rocks and fence in the foreground, are Moore's most obvious concession to the microscopic ideals of Pre-Raphaelitism.

All in all, the work expresses a formidable, massive, perhaps inflexible, character in its creator. There is nothing easy-going about it, and most American landscape of the period was pretty easy-going. Young Charles Moore when he gave it the finishing touch might proudly have repeated those memorable words of Poussin, "I have neglected nothing."

Now the problem sharply arises, did Moore simply discover this admirably composed landscape, which seems unlikely, or did he make the usual unconscious eliminations, transformations and transpositions that the good artist normally makes in the face of the bewildering complexity and richness of appearances? Or, again, did he make such creative changes quite consciously? Furthermore, if consciously or unconsciously he thus transformed the scene before him as he painted, how far was such a procedure compatible with his devotion to Pre-Raphaelite "naturalism" and truthfulness?

To answer these questions with precision I should have to reread Ruskin's *Modern Painters*. It would be a pleasure but I am living on borrowed time. Also, perhaps trusting too much to long memories, I feel that Ruskin's "truthfulness" applied to single objects, was a retail virtue, being a sort of religious assertion of the equal dignity of all God's creations, and that Ruskin left the artist pretty free in the matter of composition. I doubt if Ruskin would seriously have quarrelled with any reasonable arrangement of truthful details in order to make a fine picture. Certainly the artists he adored, Giotto, Fra Angelico, Carpaccio, Tintoretto, Turner, habitually did just that. So I believe that Moore, who had an extraordinarily fine sense for composition,

would have felt free to go beyond mere discovery and reshape his observations to his own taste. But I also feel pretty sure that he would deny that he made such pictorial emendations consciously, perhaps would have denied that he made them at all. Winslow Homer denied indignantly that he ever changed anything he saw, though the comparison of his watercolors made before the scene itself with the oil paintings of the same subjects proves that he unconsciously used the artifices that are proper to a great composer. Which lands us in the paradox that the good artist, while actually transforming appearances, should be convinced that he is imitating them faithfully—should practice the art of composition as M. Jourdain practiced that of writing prose, *sans le savoir*.

The searching nature of Moore's studies at this time is well exhibited in an amazing, unfinished pen drawing of a pine tree (Fig. 16), at Princeton as Miss Moore's gift. With the most painstaking fidelity Moore has rendered, almost needle by needle, all the complicated details, without losing the sense of vital growth, or the effect of illumination. After such a drawing one feels there was nothing more to be seen or felt. Moore knew his pine trees. There is an inscription "Catskill 1868." I hardly know a parallel for this pen drawing—anything equally minute without smallness, unless it be Ernest Haskell's famous "Big Tree" in Mr. Albert Gallatin's collection. A little earlier Moore had made what must have been a similar study of a cedar. It was to be published in *The New Path*'s album of photographs, a copy of which I have been unable to locate.*

In Moore's twenty-ninth year, 1869, he devoted himself chiefly to etching, exhibiting no pictures in the Academy shows of 1868 and 1869. The young married man may have been trying a new way of money making, or he may merely have obeyed his craftsman instinct to gain a new skill. His venture was in the spirit of the times; in the 1860's most of the prominent painters of France, England, and America tried their hand at etching. Thus Hamerton's classic book of 1868, *Etching and Etchers*, came rather as a confirmation of an established practice than as the pioneer work it is generally thought to be. Some of the painter etchers were

* As noted previously, it is possible that the subscription failed and that the album was never published.

prolific in the revived art. Millet, Daubigny, Whistler, Jacque here come to mind. Others etched episodically and rarely—Rousseau and Corot, for example. Young Charles H. Moore belonged to the latter class.

At least four of Moore's Pre-Raphaelite friends were accomplished etchers—the two Farrers and the two Hills. They must have aided and encouraged Moore in his new endeavor. Through the generosity of his former Harvard pupil, Professor Alfred M. Brooks, Princeton owns three of Moore's etchings dated in 1869. There may be others, but so far as I know these three little prints are unique. In any case they suffice to show the fineness of vision and judgment that Moore brought to his new adventure.

Let me first treat a little oblong vignette which I shall provisionally call "Overgrown Wood Road" (Fig. 17). The general bristling mass is tunneled by an old road leading to a patch of light at the end. The touch of the needle is very careful yet also delicate and light-handed. The edges are crisp, lively, and full of character. They meet the white paper in vignette fashion. Compositionally the tiny print is very thoughtful. The upward bulges of the foreground and the sagging lines of the rail fence give solid support and contrast to the apparent confusion of the thicket. But there is no real confusion. Strong and precise indications of the branching of a tree in foreground, the bristling rise of the saplings at the left, keep everything significant and accounted for. There is a dated signature, "C. H. Moore. 1869," and the time must be late summer or early autumn, for there is fruit—wild apples?—on the branches of the saplings. How Moore got the reserves that print as white dots is a puzzle which I leave to a practical etcher. The print is wholly idiomatic and American. If there is any influence it is from T. C. Farrer, perhaps the central figure of Moore's Pre-Raphaelite group, and its most accomplished and prolific etcher.

"Ledge and Spruces" (Fig. 18) may serve as title for the little upright etching which I shall next consider. An eroded, stratified ledge pushing away from the beholder is in the near foreground. From beyond it, bristling spruces push upward across a sort of chaos. Some sort of a squall, filling and blocking the distance, is indicated by swirls composed of lines so slight that they seem dry-pointed, but are bitten. Under and beyond the

domical swirl of the squall, I seem to glimpse indications of a very distant landscape on a much lower level.

This odd composition may have something to do with that "October Snow Squall" exhibited by the National Academy in 1867. The composition and meaning are about that of the oil painting "In Berkshire County" (Fig. 3)—a glimpse through a stable, natural embrasure upon a volatilized world—the contrast between what is relatively permanent and what is constantly changing in natural appearances. It is a vision, almost a nightmare, that has ever haunted the austerer sort of landscape painters. Long ago Goethe had shown how this vision of mutability dominated Jakob van Ruysdael's masterpiece, "The Jewish Churchyard." Young Moore merely indulged the vision in a less tragic and more accepting spirit. The signature again is "C. H. Moore. 1869," and if my analogy with the painting "October Snow Squall" be valid, my guess that all these etchings were made in the autumn of 1869 receives some confirmation.

The finest etching by Moore, and in my opinion one of the finest American etchings made since the Civil War, may be called "Over Mountain Shoulders" (Fig. 19). The foreground is a glaciated ledge, the sculpture of which is exquisitely and very fully rendered in fine and always directive lines. The ledge juts diagonally from right to left, ending in a sharp overhang beyond and below which the end of a wooded ridge carries the diagonal motive from corner to corner of the picture. A wooded ridge, as middle distance, repeats the main diagonal. Its edge is exquisitely modulated and expressive of structure, the main, internal modeling is suggested by an infinity of faint lines. The heavy downward thrust of the ledge and the ridge are taken up by the active branching of a sapling at the lower left. It serves as a spring or buffer, keeping also an athletic beauty merely as a form.

There is a further equipoising value in the numerous horizontal lines of the vast plain seen over the mountain shoulders, in the rolling contours of distant hills, in the left to right direction of the lines suggesting cirrus clouds turned back by the wind. The particularities of the river plain, fenced fields, patches of woodland, are in pure line, as in the upper left the turning of the river which serves as an overtone for the main diagonal motive.

For a novice in etching, it is an amazing performance. Some-

thing of its quality is surely due to study of the primitive engravers—John Ruskin had lately extolled them in his Oxford lectures—but more is due to the etcher's devout concentration on the natural beauty before him, on the thrill of doing justice to the lovely parts without losing the spacious dignity of the whole. It is rare indeed that so laborious an effort keeps all its initial joyousness. To find anything really comparable in American art (ignoring superficial analogies with Whistler's much later and slighter Venetian etchings), one must go forward half a century to those blithe or solemn masterpieces in open etched line which Ernest Haskell was making in his last years.

In these three etchings by Moore the plate is wiped clean, there is no retroussage, and, unless my eyes deceive me, no retouching in dry point. Moore chooses to stand on the inherent value of his bitten line, evading expedients which probably seemed to him to give a fake picturesqueness. Like the others, this masterly little etching is signed, and dated 1869; because of the leafless sapling, we may think of the time as advanced autumn. I am sure that the young man who made this print could have done whatever he wanted with the copper plate, could have won himself a very high position among American etchers. These three etchings are printed on a very heavy paper, almost a light cardboard.

These little prints seem to be what is left of an ambitious project to make two series of etchings. On the back of the extraordinary drawing, "The Valley of the Catskill from Jefferson Hill" (Fig. 13), which his daughter has generously given to Princeton, one may read penciled in his hand the following note; obvious omissions have been supplied by me in square brackets: "[fin]ally abandoned because I hope to make [ano]ther series illustrating the Hudson River [from] its source to the sea—& these plates [woul]d more properly belong to this last. [Ri]ver series show all the characteristic craft—Barges [], Schooners, Tugs, Canal-tugs, steamers, small sail-boats—ice-boats—Ice getting—Ice houses—[]-Yards—Rail-Roads &c &c—Mills & Bridges—[]-Side—Head Quarters, Fort Putnam, Fort Lee, Falls, []ds, Palisades, Bay & City." The rest of the back shows many tries for a monogram "C.M." or "C.H.M." which presumably was intended to be a signature for these prints.

To realize this program would have required scores of etchings, perhaps a hundred. For two of these we seem to have elaborate

pen drawings. The most remarkable of these is "The Valley of the Catskill from Jefferson Hill" (Fig. 13). Everything is minutely worked out with a very fine pen in an infinity of strokes. Tone, later to be effected by wiping the plate, is supplied by a light wash. This drawing means days of prolonged and incredibly patient work, yet the effect is broad and massive. To make an etching from it would have involved the greatest difficulty, but one may assume that Moore, the indefatigable craftsman, would have brought the thing off. That this is the original for an etching is proved by the general look, and by the character and placing of the marginal title and signature, "C. H. Moore. 1869."

When Miss Moore kindly sent me a photograph of the pen drawing, "Leeds Bridge" (Fig. 15), I thought the original might be an etching, and indeed it is a drawing made to be etched. It is a somewhat simplified copy of the landscape we have at Princeton (Fig. 12), considerable detail being eliminated in view of the proposed medium and the great reduction in scale. It is dated in 1869, a year after the oil painting, hence is a copy. For that matter, at all times Moore seems to have etched from a highly finished painting or drawing. There never was anything of the improviser about him. In this drawing he made characteristic improvements. The oblong is lengthened and shortened at the top, giving more prominence to the two fine elm trees at the right. The two right-hand arches of the bridge are cut off by the bluff. This gives more dignity and scale to the largest—the central arch— and makes the bridge a major feature. Other changes reveal Moore's infinite capacity for taking pains, his belief in second thought. The result is a loveliness, an alluring spaciousness which recalls the drawings of Claude—a paradoxical but happy coincidence, for Moore doubtless shared Ruskin's disapproval of Claude Lorrain.

What induced him to choose this minute, and for an etcher— frankly—unidiomatic method, can only be guessed. My guess is that we must look primarily to his Pre-Raphaelite ideals, and secondarily perhaps to emulation of Gaillard, who was making quite marvellous etchings in a very similar technique, using an infinitude of lines which seem too delicate to be bitten by the acid or to respond to the press. Many of the Gaillards were published in the *Gazette des Beaux-Arts*, which Moore could easily see in the public or private libraries of New York. Gaillard's silvery

etchings after the famous wax bust at Lille, and after the "Man with a Pink" long attributed to Jan van Eyck, were famous among print collectors, and may well have been Moore's exemplars.

There is a fascinating possibility that Moore may actually have executed some of these etchings. He seems to have forgotten his work as soon as it was finished—good artists often do—and when he moved to Cambridge and entered upon a teaching career, he virtually repudiated his early work, certainly took no pains to preserve it. So I venture to remind fellow print collectors that there may be undiscovered Moores compared with which the "Hundred Guilder Print" has no scarcity value whatever.

In 1880 Moore returned temporarily to print-making, as we shall see in due course.

CHAPTER VI

Studies of Mount Washington.
Watercolors of the Early 1870's.
Mount Kearsarge

THE SUMMERS of 1869 and 1870 the Moores passed at North Conway, New Hampshire, at least near it. From the Intervales of the Saco River one gets the most impressive and various views of Mount Washington and its fellow Presidents, ordinarily beginning to blue against the sky line, sometimes their noble and elaborate structure brought near and clear when the cool north wind dries up the mist, in early autumn the summits of the range capped for a day or two by snow. Moore seems to have made a veritable campaign to master Mount Washington in all its southerly aspects.

Doubtless the strategical objective of this campaign was the painting "White Mountains, Autumn," No. 405 in the National Academy show of 1872, and listed as owned by W. C. Gilman. Much research has failed to locate it. But no less than four preliminary studies make it possible for an intuitive beholder to recover at least the general look of what was probably the grandest of Moore's Pre-Raphaelite landscapes.

Perhaps the earliest of these is a minutely executed pencil drawing, dated 1869 (Fig. 20), in the possession of Moore's niece, Mrs. Theodore Krueger. It is on brownish paper, with a little wash, and in every way similar, except for its much larger scale, to those incredibly detailed preparations for etchings made the same year or earlier. It is a close-up of the great mountain, or nearly so, as if Moore intended once for all to master the greater geological structure before considering superficial details. This was a difficult task, for the architecture of Mount Washington is highly complicated, with the deep scoop of Tuckerman's Ravine and the foreshortened ridges that thrust over ten miles south to the confluence of the Saco and Wildcat.

The second drawing of the Mount Washington series (Fig. 21) is in the Fogg Museum of Art. The scene is the Presidential

Range viewed over the Intervale from a point not far from the old Intervale House. It is Moore's attempt to make Mount Washington serve as the central feature of a pictorial composition. The line lacks the strenuousness of Moore's touch at this time, especially the contours of the hills interlocking in middle distance—lines which, for him, have very little modeling value.* To help out a rapid and not too powerful sketch, a light wash has been freely laid over the whole distance. One may imagine that this drawing was hurriedly made in the open air in order to explore the compositional possibilities of the subject.

We find Moore approaching his final composition in a third drawing (Fig. 22), also in the Fogg Museum of Art. While here the line is always tense and expressive, the construction is in tone, and strong, though the tone is most subtly varied and in itself delicate, almost transparent. The view seems to be taken from a lower level than that of the larger sketch (Fig. 21), and also the oblong is raised in height. This choice brings about the major compositional changes and improvements. There is more sky above the mountains with fine clouds which have drifted nearer than the range. The base of the oblong, while showing many features already in the earlier study, has a new and picturesque feature—a bristling stump fence supporting a few loose rails. The lower point of view brings the fenced lot nearer, while diminishing its isolated prominence. Such are the major and technical improvements.

While the effect is broad and unified, certain details are rendered with a minuteness rare even for Moore—as in the geological structure of the boulders in foreground, and of the buttressing ledge at the left. One can sense an hour's work in each of a dozen such features. I trust the reader to detect many enlivening details that are absent in the earlier study.

This definitive study was certainly the later of the two, for

* EDITOR'S NOTE: The line here mentioned is a harsh outline that is not consistent with Moore's usual style of drawing which in this sketch occurs especially in the small upper section of distant and middle-distant mountains at the right. The uncharacteristic hard outlines that define most of the other hills may have been added for purposes of tracing or pouncing, or may have been the start of an attempt to sharpen and darken the whole sketch. In any case, it seems most likely that Moore regarded this as a preliminary working sheet.

the snow, sparse and merely suggested in the earlier view, now glorifies all the higher serrations. When I say later, I decline to say later by how much. It might be by a few days, or by a year. Such a drawing implies two or three days of concentrated observation and strenuous execution in the open air. I know of no finer drawing by Moore. Even that stupendous preparation for an etching, "The Valley of the Catskill from Jefferson Hill" (Fig. 13), though done within a year, perhaps within a few months, is less unified, has a somewhat unpleasing tension and starkness.

The fourth and most notable item in the Mount Washington series is a little watercolor dated 1872 (Fig. 23), and now at Princeton through Miss Moore's generosity. I leave to the reader the pleasure of discovering for himself the numerous small changes, always improvements, in composition. Obvious and very important betterments are the sky and near foreground. The sky has been worked into a sort of inverted dome, and thus related to the domical mass of the mountain. There is less minute detail in the boulders in foreground. The eye is not arrested on its way to the big expanse of the Intervale. Everything now works for spaciousness. The early autumn russets of the trees are very tenderly expressed, while the floor of the Intervale retains its summer green.

There can be little doubt that the painting "White Mountains, Autumn," exhibited by the National Academy in 1870, followed very closely the composition finally worked out in this watercolor. If so, the disappearance of that painting is deeply to be regretted. Given the material, it must have been more colorful than "Leeds Bridge" and more urbane in expression. No work of Moore's could have exceeded it in grandeur of effect—not even the best of the watercolors painted a few years later at Simplon Village.

If only to complete the Mount Washington episode, two watercolors datable about 1870, perhaps a little later, may be here briefly considered. Neither shows the Intervale. A finished watercolor owned by Mrs. W. H. Thompson, at South Tamworth, New Hampshire, makes much of scattered village houses and a white church spire in near middle distance. Unless my memory fails, the point of view is the hills sloping down towards the highroad near the village of East Branch.

The other watercolor, at Princeton—reproduced on the title

page of this book—, is only a lay-in, the emphasis being on the structure of ledges at the right, which in the finished sketch would have been in near middle distance.

These not very important sketches are here introduced chiefly as evidence of the fascination that Mount Washington exercised upon Moore.

Moore painted very little in his early years at Cambridge, but continued to sketch in watercolors during his summer vacations. Two very minute and brilliant coast scenes in the Fogg Museum of Art are tentatively dated about 1872 by Professor Arthur Pope, a pupil of Moore's and an excellent judge of his work. For me these two watercolors mark the end of Moore's Pre-Raphaelite phase.

The scene seems to be the Maine coast well "down East." The sheet entitled simply "Landscape" (Fig. 24) is of a tenacious minuteness in the foreground ledges and boulders, while throughout as atmospheric as the crystalline air permits. It is supremely skillful, perhaps a little unfocused, as Pre-Raphaelite works are likely to be. It offers almost a surplus of fidelities and felicities for a casual beholder.

No such reservation applies to the watercolor, officially and unimaginatively called "Rocks by the Water" (Fig. 25). It is a very studied portrait of a huge boulder with a setting of smaller rocks near by, and a wooded shore in middle distance, no distance except a slightly veiled sky. The effect is paradoxically prophetic of Alfred Stieglitz's photographs still thirty years in the future. What counts most is intensity of vision accompanied by a certain reverence for the thing seen. Secondary but still important, is the choice of surroundings which make the central theme count. If this watercolor be indeed Moore's valedictory to Pre-Raphael-itism, it is a worthy farewell.

In treating at this point the latest landscape in oils I have found showing Pre-Raphaelite tendencies, "Mount Kearsarge" (Fig. 26), monogrammed and dated 1872, I anticipate my narrative by a couple of years. This admirable little painting was courteously ceded to Princeton by Miss Rosamund Clark of Boston. It brings with it the interesting family tradition that it was given in 1875 to her father, a physician, for his skillful and considerate treatment of little Bessie Moore when ill with scarlet fever. It was painted in Kearsarge Village in 1872, during

Moore's first vacation after the move to Cambridge. I think I recognize the exact scene, the little dam on Kearsarge Brook, in which I have ruthlessly killed many fingerling trout, almost opposite the famous Merrill House.

The entirely lusterless surface looks like tempera, but it is oil pigment from which most of the oil has been eliminated and replaced by turpentine. The color scheme is a contrast of tans and pale warm browns with the grayish blue of the mountain dome which rises, without any middle distance, directly above the log dam and the sawmill. The tonality then is much that of "Leeds Bridge" withal less somber, and the handling is equally crisp and tense. But the tension no longer seems imposed and labored. It is a gracious little picture, very large in scale, with a nice blend of what is exhilarating and tranquilizing in the scene itself.

The minute yet easy drawing of the disorderly pile of newly sawn boards is simply amazing. Conceivably Moore painted it with his eye on the object, but it would have been a job to drive a painter to distraction, and I prefer to think that he after repeated observations painted his board pile out of his head and to suit himself.

In color this is the finest Moore I have seen. The prevailing tone is a muted rose that deepens to russet in the foreground, and cools to a warm gray in the mountain—the contrast and gradations of an ethereal beauty. The time, I judge from the relative absence of cast shadows, is late morning. The well-fused warm glow from the east fairly volatilizes the mountain mass, though its essential structure is strongly if most delicately indicated.

The importance of this little picture to me is that it shows that Moore at thirty-two, having outgrown the defects of his Pre-Raphaelite manner, had retained its qualities. Imagine big landscapes of this merit exhibited widely. They would have been notable at a time when George Inness was painting his finest Italian landscapes, and Homer D. Martin was showing his splendid views of Lake Champlain and the Adirondacks. In short, Moore might easily have anticipated, in a more sensitive and painterlike fashion, our more recent and possibly overpublicized painters of the American scene. But Moore was already committed

to a future of strenuous academic teaching and research. He no longer regarded himself as a professional painter.

In a letter to his new mentor, Norton, written in 1866, Moore had expressed a fairly religious devotion to his new calling as a landscape painter, and declined Norton's suggestion of starting a class at Cambridge. Also, three years later Moore was planning a series of over a hundred etchings of Hudson valley subjects. With his minute methods it would have taken several years to etch and print this set.

But in 1871, he accepted an instructorship in the Lawrence Scientific School, abandoned the project for the etchings, for which he had made serious preparations, ceased to be a professional painter, dropped painting in oils, and painted in watercolors as an avocation only. For nearly forty years he was to be a teacher.

Here we have a strange decision. A landscape painter, energetic, talented, and apparently successful, in his early thirties, and steadily advancing in skill, turns his back on a promising career in favor of a minor academic position. Such a *volte face* needs interpretation.

First we should recall that at this moment of decision Moore had been a professional painter for nearly twenty years. Much later he told his daughter that painting for a living had always been irksome to him—a rationalization perhaps, but also a partial explanation. I think he underestimated his own talent, and may have felt that he had reached the limit of his accomplishment. If so, I feel he was wrong, believing that he could have held his own with his best contemporaries. But his ideals were high. In the letter to Norton, already quoted, Moore sharply distinguishes between a creative and a merely descriptive art. At twenty-six he was contented with the homage to nature implied in a descriptive role. Five or six years later he may easily have been dissatisfied therewith, may have regarded himself as a failure. In this case the shift to a new and honorable career would be natural. Finally, from boyhood he had had the generous habit of helping his less prosperous kin and saw no future abatement of such claims on his loyalty. These reasons may have combined to make the prospect of a steady income attractive. And, after all, his salary of $1,500 was for the times ample, its purchasing power many times that of today. Beyond this, Moore valued his prestige, and on this

ground the dignity and stability of the Harvard connection will have had a strong appeal. Especially when that appeal came from so persuasive a patron as Charles Eliot Norton.

We have sketched briefly Moore's career as a professional painter, covering the thirteen years from 1858 to 1870. During this time his method was laborious and slow. There were competing activities. In the years from 1866 to 1869 he was much preoccupied with etching. Obviously he painted preferably in the open air, which was possible only when the weather was reasonably good. Under these limitations his production of finished pictures probably was small. Still we can hardly imagine him painting less than six of his rather smallish landscapes every year. That would imply a total of seventy-eight, for a round number, eighty, finished landscapes in oils for his thirteen professional years. Of these eighty I have located twelve, and thirteen are listed in exhibition catalogues or mentioned in letters. That is, about a third of Moore's probable output up to the end of 1872 is available. Two-thirds, more than fifty, of his finished pictures of this period have evaded my research, but presumably exist, for whoever heard of an owner deliberately destroying a "real oil painting"? It is my hope that this book will encourage a more successful hunt for these pictures than mine has been. Happily those available for my study, supplemented by drawings, etchings and watercolors, adequately represent Moore's development.

It may be added that Moore never painted a big oil painting calculated for effect in exhibition. While Inness was painting "Peace and Plenty" and "Barberini Pines" Moore was painting little landscapes. This may imply modesty or conscientiousness, or both. To have painted "Peace and Plenty" in Moore's Pre-Raphaelite fashion would have taken years. So quite apart from modesty, in which Moore never indulged to excess, there were sound material reasons for his abstention from that Barnumism which Cole, Bierstadt, and F. E. Church had successfully inaugurated.

CHAPTER VII

At Harvard.
Teaching in the Scientific School.
Temporarily Ceases to Paint

Since Moore owed to Norton his call to Cambridge, it is tempting
to enliven these pages by presenting the Sage of Shady Hill as
Moore's evil genius or as his guardian angel—his evil genius, as
diverting from landscape painting the most promising young
American landscapist of the moment; his guardian angel, in pro-
viding Moore with a most congenial and highly distinguished
academic career. But such black or white labels are generally
misapplied, and would be in this case. Perhaps the sagacious and
perceptive Norton realized that ambivalence in Moore's character
which made him love to paint landscapes but hate to sell them.
It seems to me probable that Moore would sooner or later have
turned his back on his high promise as an artist, and might have
sought some method of breadwinning far less agreeable than that
willing servitude which was his lot at Harvard. Later we shall find
good evidence that such was the case—that Norton's role toward
his young protégé was after all that of good angel. All the same,
I deeply regret Moore's great refusal and Norton's benevolence,
if only because any considerable success in landscape painting
seems to me more precious than a lot of worthy or even distin-
guished careers as professors and art historians.

In early autumn of 1871 Moore went to Cambridge to serve
as Instructor in Freehand Drawing in the Lawrence Scientific
School. The move to Cambridge virtually marked the end of
his creative period as an artist. So far as I know, he painted only
one landscape in oils after 1871. He ceased to exhibit with the
National Academy. Watercolor and pencil, which he used con-
stantly and most skillfully in his teaching, became his favorite
mediums, and what few landscapes he thus executed were done in
his travels or on vacations. Landscape painting had dwindled to
a mere avocation. A new and brilliant career as a teacher and as
a critic of architecture lay before him, but before treating this

familiar chapter of his life I must complete my proper theme, Moore as painter and etcher, with a brief chapter which could be called Creative Aftermath.

As for Moore's work in the Lawrence Scientific School, it is hard to imagine a more uncongenial task for a man of his character and accomplishment. Certainly the students—largely engineers—he would have in his classes there were hardly to be expected to take a great deal of interest in freehand drawing. Why then did Moore accept such a job at all? And, having accepted it, how could he stomach it for all of five years?

An obvious explanation would be dire need of the salary. But Moore was selling his landscapes, and he and his wife had slender resources of their own; they were comfortably off, and by no means needy.

Or Moore may have gone into his new work as a reformer, hoping to spread the gospel of Ruskin. A possible view, but an unlikely one. There is, however, a little evidence for it, in a letter of Moore's to Charles Eliot Norton, written on February 3, 1873, in which Moore reports, "I now have over 40 students in my classes. . . . I have followed Mr. Ruskin's teaching so far as I could." One fears that "Mr. Ruskin's teaching" came off rather badly in competition with the standard methods of indication.*

Sketching in watercolors remained a summer recreation in these early Harvard years. The fine watercolor "Schooners, Ironbound Island, Maine" (Fig. 27), a gift of Miss Moore's to Princeton, shows that Moore about 1873 had relaxed something of his Pre-

* EDITOR'S NOTE: Whatever Moore's reasons for accepting a position as teacher of freehand drawing in the Scientific School, he presumably did so at the urging of both Charles Eliot Norton and President Eliot. Professor Arthur Pope writes, "I suspect that President Eliot had as much interest as Mr. Norton in Moore's appointment, for Mr. Eliot believed firmly in the value of free-hand drawing as providing training in observation as well as affording a useful and often economical means of expression for anyone. Later on he was largely responsible for persuading a reluctant faculty to consider courses which included practice in drawing and painting as entirely proper to be counted for the A.B. as well as S.B. degree.

"Incidentally, it is perhaps surprising to note that Mr. Moore's early courses in free-hand drawing and water color were listed in the program of courses not only for engineers but also for students of natural science including chemists. This must have had Mr. Eliot's approbation." For Eliot himself was a chemist.

Raphaelite tension. Moore, a lover of boats, shirked no line of the complicated rigging. What is remarkable in this unfinished sketch, is an accuracy of color perception unusual at the time—when local color was still just local color. The warm grays of the slack sails are charmingly and truthfully observed. Here and there one sees the slight but very precise pencil indications—very unlike the helpful scribble with which many a good watercolorist starts. At all stages any sketch of Moore's is finished, as Whistler, a matter of ten years later, was to remark as a general merit of good work.

A watercolor of a sawmill (Fig. 28) undoubtedly made in 1874 at Moore's new summer home at West Boxford, Massachusetts, indicates that he had relaxed his Pre-Raphaelite ideals in favor of a more pictorial style. From Moore's essay in *The New Path* it is clear that he regarded the minute representation of objects as a phase of tutelage and not as an end in itself. The artist invents, and is free to do so. This view is repeated in Moore's essay on "John Ruskin as an Art Critic," published in *The Atlantic Monthly* for October, 1900 (p. 438), and in an important manuscript essay on the "Pre-Raphaelite Movement," which I have read through the courtesy of Miss Moore. Another manuscript, on "Venetian Painting," extols Titian's methods. These manuscripts are now in the Houghton Library, at Harvard, as Miss Moore's gift.

It becomes clear that the hold of the Pre-Raphaelite teaching on Moore was chiefly moral and provisional. The above-cited little watercolor of 1874, "Sawmill at West Boxford" (Fig. 28), now at Princeton through Miss Moore's generosity, shows Moore liberated, and now painting for his own pleasure. Everything is still precise and specific, the drawing of the forms complete and masterly, but the old tension, at its maximum in the White Mountain drawings, is absent. This watercolor is relatively easy-going, if without negligence, and less insistent. New is the attention paid to the very complicated illumination. It is a quietly skillful performance, of a merit that is not perceived at a hasty glance. Moore's later watercolors will show a still freer method and a more direct attack. By a justifiable dualism Moore will remain the Pre-Raphaelite when dealing with his students, knowing that it is the best training for beginners, while his own work, unhappily to be merely episodical, will be free from isms of any sort, being guided by a fine balance between devotion to natural

appearances and a due respect for that noble tradition of painting which grew to perfection at Venice.

Except for the West Boxford sketch and the Mount Kearsarge I know of no work by Moore that can clearly be dated between 1871 and 1876. This may imply a sort of rest from a very strenuous young manhood and as well a dogged devotion to his new and probably uncongenial task of instructing his small group of undergraduates in freehand drawing.

There are reasons for supposing that these lean years were arranged by Norton, and perhaps by his cousin, Charles W. Eliot, the new President of Harvard, as a temporary and probationary period for Moore. In 1869 the brilliant and also eminently solid Professor of Chemistry became the first scientist president to break a long succession of divines. He was surely in touch with his cousin, Charles Eliot Norton, whose native and also highly cultivated prudence made him an ideal confidant and adviser. In 1874 Norton was appointed to a professorship in the fine arts, and was in correspondence with Moore concerning the organization of what I believe to be the first really well-planned department of art in any American college.

It initiated a dual approach, which has been widely imitated, and too often caricatured, in hundreds of American colleges. Norton, preeminently well-fitted for the task, was to cover the history of art in its broadly cultural aspects, Moore was to conduct practical exercises which would supplement Norton's teaching, and aid in appreciation. Since both were convinced Ruskinians, these exercises were sure to take most seriously into account "the methods of Mr. Ruskin."

CHAPTER VIII

European Wanderjahre.
Working with Ruskin.
The Mezzotints

In 1874 Moore was transferred from his instructorship in the Scientific School, to the same grade in the College, and was given a leave of absence of a year at a salary of $1,500 to prepare himself for his new teaching, and especially to gather the materials which should be exemplary for his students. In June of 1876 Moore, with his somewhat invalid wife and their little daughter Bessie, sailed for England. Moore carried a letter of introduction from Norton to Ruskin, and presented it without delay. He telegraphed the erratic sage from Queenstown, and received the hospitable reply: "Yes and welcome. Your bed will be ready, so glad you are safe."

Moore's account of what must have been a very high spot in a life generally tranquil, was written to Norton from Oxford on June 25, 1876: "Mr. Ruskin received me in a truly affectionate manner." Ruskin arranged that they should spend September together at Venice.

About a fortnight after this meeting, Ruskin wrote to Norton, "I was of course delighted with Mr. Moore, and had most true pleasure in the time he could spare to me, increased by the feeling that I was able to show him things that he felt to be useful. . . . Moving Venicewards to meet Mr. Moore in Carpaccio's chapel."

Apart from the natural amiability of a master toward a new and promising disciple, the eminently unstable, even hectic master may have found support and solace in the very stable poise of such a disciple as Moore. In any case Ruskin made an avowal strange enough in itself, and stranger since made to a new acquaintance. I cite again Moore's Oxford letter to Norton.

"He [Ruskin] said there had been a blight in the atmosphere for the past five years which had destroyed the color of the clouds and the purity of the sky."

Sinister enough, this foreshadowing of those mental derange-

ments that first clouded, then obscured, Ruskin's last years. No meteorologist would have noted any marked difference in England's weather between 1871 and 1876, but these were the years pathetically marked by Ruskin's untimely wooing—he was in his sixties—of the Irish schoolgirl, Rosie La Touche. She had refused him on religious grounds, being a devout Catholic, and had died only a few months before Moore's visit to Ruskin.

A letter of October 8, 1876, to Norton tells that the Moores had been three weeks at Venice, and that Moore had been chiefly busy with Ruskin copying Carpaccio's "Dream of St. Ursula," which for their convenience and privacy had been moved from the gallery to another room. The imagination cannot refrain from playing about the situation. After Rosie's death, Ruskin had made Carpaccio's St. Ursula a mystic embodiment of Rosie's spirit. How much awareness of this was there between master and disciple, as for days, and probably mostly in silence, they copied together Carpaccio's loveliest creation? Obviously such a question cannot be definitely answered, but Ruskin's strange infatuation for Rosie was more or less common knowledge. Moore doubtless knew something about it, and Ruskin must have known that Moore knew.

Meanwhile Ruskin, incorrigible cavalier of little girls, had made friends with golden-haired Bessie Moore, teaching her to row "with a little oar," as she proudly wrote to a playmate in England.

The general relations of Ruskin and Moore are expressed in letters of Ruskin to Norton dated in the autumn of 1876 and early in 1877. On October 5 Ruskin writes: "I am very much delighted at having Moore for a companion—we have perfect sympathy in all art matters and are not in dissonance on any others." On February 5, 1877, he writes, "I have been very happy—in such sense as I ever can be, with Mr. Moore, he is so nice." The month of companionship which Ruskin had originally proposed had stretched to nearly four.

Now while Moore had had an unforgettable experience, and surely had learned much, if discursively, from his new master, his own preparation for teaching at Harvard must have fallen behind. That involved making a considerable group of copies for his students to study and recopy—copies of Ruskin's beautiful drawings, of significant details of old sculptures, mostly archi-

tectural, and of paintings. All this had gone so slowly that on December 31, 1876, Moore wrote Norton that he felt the need of extending his preparation for another year, but could not expect the continuation of his salary of $1,500.

Ruskin knew the situation and offered Moore a salary of £300 to teach for St. George's Guild at Sheffield. The offer probably tempted Moore, already a pronounced Anglophile, but he felt his duty lay at Harvard. Ruskin then agreed to pay, if needed, £300 for half of Moore's teaching material. This guarantee hung somewhat heavily over Moore, for he wished to keep all his copies, but it made the second year possible. In the end with some aid from Norton the material went undivided to Harvard, where it still is cherished.

Most of the winter of 1877 the Moores were in Florence where he haunted the galleries and churches, adding considerably to the collection of exemplary details he was making for his future students at Harvard. Much of the summer of 1877 was spent by the Moores at Simplon Village, in constant association with Ruskin. Moore wrote to Norton that Ruskin was "in an extreme state of mental depression but very sweet and tender."

The years 1876 and 1877 witnessed the final flare-up of Moore's creative genius in the form of eight closely studied watercolors, all apparently of Italian scenery. Several were made at Venice, one at Florence, the rest at Simplon Village.

Technically this work is both solid and brilliant, more colorful than his oil paintings. The style owes nothing to Ruskin—is not specifically Pre-Raphaelite, except where the subject must be either scamped or searched minutely. Moore, of course, never scamped anything.

In general these Italian watercolors are broadly brushed in and except for their resolute construction are by no means anomalous at the moment when Whistler and Winslow Homer were perfecting their style in watercolor. The sketch of a Venetian Doorway (Fig. 29), one of Professor Norton's prized possessions, and now owned by his daughter Miss Elizabeth Norton, might almost be called Whistlerian in its sensitive rendering of the infinite variations of saturated color on these graciously crumbling stones of Venice.

I reproduce one of the most brilliant watercolors of Simplon Village (Fig. 30). It is in the Fogg Museum. It gives a sense of

atmosphere, though the air is washed clean, and the noble relation of the snow-clad peaks and heavy clouds to the humble forms of the village houses is admirably realized.

A purist might cavil at the free use of opaque white in these watercolors, opining it were more idiomatic to make the reserved paper do the work. Such a cavil might seem just. But if a blemish it is surely a minor one, and Moore's very deliberate genius could not reasonably be expected to adopt the brilliant short cuts of such watercolorists *pur sang*, as Winslow Homer and John Marin. For that matter, Moore had behind him the precedent of Turner and Ruskin. Apart from this, Moore's handling is of singular directness and purity. He got out of watercolors about all that the trickiest and most spoilable of mediums can be made to yield.

Of contrasting excellence is a watercolor at Princeton, presented by Miss Moore, which I shall call "Storm Clouds over Simplon Village" (Fig. 31).* The little buildings are seen beyond fields where laborers move about. Murky clouds fairly boil in the defile beyond and high above the hamlet, and a mountain at the left exudes forcefully many white torrents and waterfalls. The method is broad, the effect spacious, ominous, fairly Turneresque. As in all the drawings of this summer, there are apparent returns to Moore's Pre-Raphaelite methods, but they are only apparent. Take the indication of a shroud of fir trees over the mountain to the right; it is not a question of indicating individual trees, but of finding an accurate and expressive formula which will suggest the whole mass. It is a strong and spacious work, distinguished by those qualities of breadth and mystery which Moore had gradually come to value.

We have at Princeton three more watercolors painted at Simplon Village in the summer of 1877. One is finished, two carried far. Perhaps the most notable is an unfinished close-up of a watermill (Fig. 33) very carefully studied in the russet and dull silver tones of old timbers, roof tiles and boulders. Moore's method is shown most instructively in the unfinished sketch (Fig. 32) of a path curving to the head of the village street with, beyond and

* EDITOR'S NOTE: This watercolor is monogrammed "C.H.M.," and surprisingly bears the date of 1881, some three years after Moore's return from his leave abroad. Presumably he completed the watercolor, or else did it over, only at that later date.

above, high mountains covered with firs at their bases and striated with snow on their crests.

Moore rejects the usual procedure of the watercolorist, which is gradually to bring an all-overish start into definition. Instead, he follows what seems to be the practice of the old masters—finishing once for all the most important features. This is shown in the sketch before us (Fig. 32) in the rails of the path, in the flowers in the foreground, in the solid blocking in of the village, the details of the mountain ridges, etc. Any "finishing" additions would have been subordinated to these chosen and fixed features. Whereas with the usual procedure such features would have been ultimately subordinated to the character of the lay-in. Moore's method, in short, is highly voluntary. From the beginning he sees the end, trusting nothing whatever to those happy chances upon which the amateur watercolorist counts greatly, and even the professional, a little.

Of the merits of these little works of art Moore was fully aware, for some half-dozen years later he actually sought publicity, probably for the only time in his life, for five of these designs by offering for subscription his own etched and mezzotinted copies.

Remarkable as these watercolors are, they yield in importance to a little pencil drawing of Ruskin (Fig. 34), made in 1876 or 1877, probably at Simplon Village, where Moore and Ruskin had more leisure than they had while actively studying and copying at Venice. Just as realized form, the little drawing is amazingly complete, but it escapes the usual photographic suggestion of this type of drawing. As characterization it is profoundly tragic, but the expression is obtained objectively by the finest observation and representation of the forms. There are none of the short cuts one expects in a poetized or dramatized portrait. One may guess that Moore's attitude was more diagnostic than sympathetic. Yet much of the at once glorious and frustrated life of John Ruskin may be read in this portrait—the pampered boy disqualified from the first from using his great powers reasonably; the voice crying in an aesthetic and economic wilderness only to be praised not for its meaning, but for its eloquence; the humiliated young husband who couldn't play a husband's part; the aged suitor for a schoolgirl who died. Much of this surely may be read in this sullen visage with the shadow of insanity upon it,

mistrustful of itself and of the world. Here we visualize that "extreme state of mental depression" which Moore noted in the letter from Simplon Village.

One may feel it a cruel portrait for a disciple and friend to make of his master. Yet Moore had his master's warrant for an objectivity that was neither kind nor cruel, for an absolute fidelity to appearances. Moreover, it should not be forgotten that Moore, while he loved and venerated Ruskin, always maintained a certain detachment. At all times such detachment may have been Moore's quality as a thinker and defect as an artist. From Moore's article of 1864 in *The New Path*, to his remarkable *Atlantic* essay, after Ruskin's death, on "John Ruskin as an Art Critic," it is clear that he was aware of the limitations of Ruskin's doctrine, and equally aware of grave weaknesses in Ruskin's character. On the whole, one should not regret an objectivity that has given us one of the most extraordinary human documents that nineteenth century portraiture affords.

Moore also painted in oils a small half-length portrait of Ruskin. It is in the collection of Professor Paul J. Sachs. It is in every way less remarkable than the drawing. The hands, sensitive in the extreme, might even seem more important and telling than the shyly benign mask. This is Ruskin as everybody could see him, distinguished in technical construction but almost neutral as characterization. Between these two portraits there can hardly be an interval of more than a year, perhaps indeed both were done in the same summer. I may guess that Moore made the oil painting as a sort of public record, while he made the devastating drawing for himself.

By early summer of 1878 Moore's *Wanderjahre* were drawing to a close. On June 30, 1878, he wrote Norton from Enfield near London, arranging an advance of £40 to enable him to bring back the half of his copies which Ruskin had underwritten. Moore adds, "On Mondays I go to Orpington to have instruction from Mr. Allen in engraving on steel." Evidently the plan of reproducing some of his watercolors in mezzotinted etchings was already in mind. The plan was carried out two years later. Mr. Allen, of course, was Ruskin's printer-publisher who made or superintended the beautiful engraved illustrations for the authorized edition of Ruskin's complete works. By midsummer of 1878 the Moores were again in Cambridge.

Perhaps I may as well advance the clock by a couple of years and insert here as a sort of footnote the story of the mezzotints.

Toward the end of 1880, Moore issued a circular offering at subscription five mezzotinted etchings from steel plates. The circular contained a notice, signed with the easily recognized initials "C.E.N." of Charles Eliot Norton, reprinted from the *Harvard Register* of November 1880. There was also a friendly advance notice by the anonymous art editor of *The Nation*. Perhaps a Christmas sale was hoped for. The very moderate price, five dollars for the regular pulls, ten dollars for proofs before letters, should have been attractive to a thrifty art-lover in holiday mood. If such was the hope, it met frustration, for the set must be one of the rarest items in the field of American prints. I know only of three sets in print rooms—in the Boston Museum of Fine Arts, in the Fogg Museum of Art, and in the Princeton Art Museum.

The edition had been planned in 1878, when Moore took lessons in mezzotinting on steel from Mr. Allen, Ruskin's printer and engraver. Moore, nothing if not a planning person, probably knew already which watercolors made during his Italian days were to be reproduced. Mezzotinting on steel is a very slow and laborious process, and the plates were probably worked one by one in the two years or so between Moore's return from Europe and the appearance of the prospectus. It is a mere guess, though, I feel, a pretty good one, that the plates were made in the order of the numbers they bear in the finished state. One may also reasonably imagine that Moore had in mind starting, after Turner's precedent, his own *Liber Studiorum*, which could be continued in issues of five etchings each, should the sales warrant. In choosing so durable a technique as mezzotinted etching on steel he probably hoped for a large printing. Nothing of the sort came about. The choice of this very difficult medium may easily have been prompted by the mishaps which befell Turner's *Liber*. Because that had been engraved on copper, the mezzotinted or aquatinted surfaces soon wore out, and wore out unevenly. There was a constant repairing of this damage, with the result that, save for a few very early issues, there is no such thing as a *Liber* of uniform impressions.

In giving these prints merely qualified praise, it should be recalled that Moore had tackled a new and difficult process which,

had he had encouragement to carry on, he would have mastered. The very conscious and patient craftsman in him would presumably have worked out a better balance of line and tone than we find in these five etchings.

Of course, he could have taken the easy way of working on copper and having the plates steeled. But such a short cut would have been repugnant to the scrupulous craftsman in Moore. Besides, he may have felt there was some loss of quality in steeling a copper plate. He probably knew that the coppers of Whistler's "Thames Series" had been steeled, to the considerable disadvantage of the impressions. So he made his mezzotinted etchings the hard way.

Oddly these five prints have less print idiom than the three little etchings made over ten years earlier (see pp. 32-34). The five Italian prints look too much what they are, copies of highly finished watercolors, and being in brown monochrome, they have an almost photographic aspect not wholly agreeable to a print lover. The carefully balanced mezzotinted areas yield the sense of place, and give, perhaps with a touch of primness, a feeling of truthfulness. Unlike the vigorous etched outlines with which Turner himself started each plate of the *Liber*, Moore's etched preparations, of which pulls may be seen at Boston, Cambridge and Princeton,* are slight and scratchy, hardly more than the pencil indications with which a prudent watercolor painter is likely to begin. Moore's etchings virtually disappear in the finished plate, were meant so to disappear.

Here there are two noteworthy exceptions. "The Old Doorway, Venice" (Fig. 35), used the etched preparation to the full with charming results. In this Moore has followed the lead of Ruskin's admirable illustrations for *Stones of Venice*. As noted above, the watercolor for this print belonged to Charles Eliot Norton, and is as I write in the possession of his daughter. It is possibly the richest and most sympathetic painting from Moore's strenuous hand. The slight etching for the mezzotint "On the Lagune" is to me enchanting, while the finished print (Fig. 36) is, with "The

* EDITOR'S NOTE: To Mather's knowledge only the Fogg Museum and the Museums of Boston and Princeton have a complete or virtually complete set of states. In the published state all these mezzotints are lettered in the margin, "Issued by the Harvard Art Club" and "Drawn and engraved on steel by Charles H. Moore."

Doorway," superior in luminosity and richness to the three others of the series. These two charming etchings confirm my opinion expressed above that with practice Moore would have mastered his new and difficult medium.

CHAPTER IX

Building up an Art Department

DURING THE MOORES' ABSENCE, their house on Follen Street had been entered by burglars and maliciously sacked. Dr. Alfred Worcester, then a recent Harvard graduate, and in charge of the home, writes me that "among the debris there were no oil paintings." Possibly a few had been stolen as seeming more valuable than the great mass of drawings and watercolors. More likely, I believe, is my surmise that Moore in one way or another disposed of virtually all his oil paintings before moving to Cambridge. The wreck that Dr. Worcester graphically describes to me seems rather the deed of bad small boys than of professional burglars with art-collecting instincts.

In September of 1878 Moore offered FINE ARTS 1, "Principles of Design in Painting, Sculpture and Architecture. 3 times a week." This ambitious course consisted of informal lectures illustrated and reinforced by drawing with the pencil or in watercolor. Here is the germ of the famous Harvard Laboratory Method of teaching the history and appreciation of art "by doing."*

The purely historical approach was represented by Professor Norton in what soon came to be his famous FINE ARTS 2. This beginning of a notable art department had to cope with the new situation caused by President Eliot's revolutionary extension of the elective system, which made departmental and individual courses highly competitive. Easy courses attracted students; courses that were both easy and interesting, like those of the geologist, Professor Shaler, drew in masses of undergraduates who, disliking work, liked to be amused, and had no objection to being incidentally edified.

Professor Norton, with his genius for irritating the dull or

* EDITOR'S NOTE: According to Professor Arthur Pope, "the 'doing' to which Mr. Mather refers was aimed to provide a rational basis for understanding and critical judgment. It was the general point of view involved in this that gave a peculiar character to the teaching of Fine Arts at Harvard for the next seventy years."

lazy undergraduate while fascinating the serious student, was ideally equipped to meet this new competition.

Moore's situation was less assured. As I read him, he never made things easy either for himself or for others, and had few attracting grace notes in his sturdy character. He met the situation, doubtless with Norton's approval, probably on Norton's suggestion—for the idealist of Shady Hill had paradoxically abundant worldly wisdom—, by judicious and truthful advertising. In December of 1878 he exhibited the best of the teaching apparatus he had gathered in his two European years, and told how he meant to use it, in a *"Catalogue with Notes of Studies and Facsimiles . . . to be used as Exercises in Drawing.* Exhibited by the Harvard Art Club in 2 Thayer Hall."

This visual anthology of eighty-five selections—including a few photographs—deserves a brief analysis. Moore had learned from Ruskin, who in turn had learned from his beloved Primitives, that the best way to begin training the eye and hand is to get the student to study and copy fine drawings. Accordingly Moore's apparatus was what he felt most likely to develop taste in a Harvard undergraduate, or, for that matter, in any serious young person.

The most salient feature of this anthology was Moore's admirable watercolor copies of details of pictures by such great Italians as Fra Angelico, Botticelli, Filippino Lippi, Gentile Bellini, Carpaccio, Titian, Tintoretto, Veronese. There were eight good copies of Turner's watercolors, and original drawings by Prout. Moore himself, sometimes copying Ruskin, provided many studies of details of sculpture and architecture, mostly Italian. But his taste reached out to Greek vase painting, Egyptian painting, and borders of Gothic manuscripts.

Contemporary artists represented were only Burne-Jones, a protégé and friend of Norton's, and the very talented American precursor of Impressionism, A. Godwin, who has only recently been duly studied.

Moore's initial course, which covered architecture, painting and sculpture, with reading, lectures and practical exercises, was clearly overloaded. So in 1881 it was divided into two courses— "Principles of Delineation, Color and Chiaroscuro," and "Principles of Design in Painting, Sculpture and Architecture," with reading from Viollet-le-Duc and Ruskin. These two courses be-

came staple alongside Professor Norton's large course on the cultural aspects of the fine arts.

There is general agreement among Moore's students, many now celebrities, that he was an inspiring teacher in these rather small courses. The numbers grew, but were never unwieldy. The class met around a big table, whether listening to informal lectures, or drawing or painting. Apart from reading and taking notes on the lectures, the undergraduates had the rare advantage of watching Moore's amazing skill with pencil and brush, as he offered suggestions and made corrections on their work. Moore, according to his disciples, lectured "informally" on such themes as Line, Color, Chiaroscuro, Perspective, Mystery, etc. Here it is well to insist that an "informal" lecture by Moore was most painstakingly prepared. Fortunately some of the typed lectures, or at least their substance, are by his daughter's gift in the Houghton Library. They are finished essays, with hardly a correction, and, incidentally, they should in my judgment be published.

They attest the thoroughness of Moore's character. Although the situation indicated a chatty and discursive method, Moore trusted nothing to the moment, left little scope for happy improvisation. The manuscript, as the immaculate condition of typed samples attest, was not brought to class, but *scriptum est* was always reassuringly in the lecturer's mind.* His teaching must have been eminently clear, terse and businesslike—and quite free from that talky-talk which is too often supposed to make any dosage of instruction in art palatable. As Moore took on new activities, as author and museum director, he called in young assistants, chiefly on the practical exercises. Mr. Martin Mower and Professor Arthur Pope are prominent on this roll.

When Professor Norton retired, in 1898, his famous course was divided, the classical period being assigned to newcomers beginning with Dr. Edward Robinson, the post-classical period being covered by Moore himself. The Houghton Library again has typed copies of what must be the substance of lectures for this course—these are careful studies of such subjects as Venetian

* EDITOR'S NOTE: Professor Arthur Pope believes that these typed manuscripts were probably copies of the original notes which were always written in longhand and were taken to class.

Painting, Florentine Painting, English Pre-Raphaelites, etc. Much of this material deserves publication.

Whoever followed Norton as a lecturer faced a staggering comparison. Norton's method was subtle and circuitous. He charmed, bewildered, often offended his hearers. When an undergraduate said, "Let's go and hear Norton drool," it was an invitation to a stimulating experience. The Sage of Shady Hill played knowingly on the sensibilities of his audience. Not so Moore who made a massive frontal attack on the very various and often resistant minds of his hearers. He was entirely incapable of what we may call Norton's moral pyrotechnics—Norton's best resource against the complacency of the majority of his hearers.

Naturally then the report of Moore's lectures, especially from early hearers who were conditioned by Norton's legend, is that Moore was on the whole a dull lecturer, with a somewhat Anglified enunciation which was uncongenial to the undergraduates of the decade from 1895 to 1905 or so. However, there was a remnant that appreciated the solidity of the teaching that Moore gave them. He read these lectures, which always makes against a vivacious delivery. Happily there still are hearers who like the guarantee of careful preparation implied in a visible manuscript.

Toward the end of his teaching at Harvard, in 1901-02, Moore offered a new course on the "History and Principles of Engraving." Here he could use two important collections, the Gray and the Randall collections, which had been long on loan in the Boston Museum of Fine Arts. At Moore's instance these collections had been recalled by Harvard University, to become the foundation treasures of the new Fogg Museum of Art. I need not follow further the history of the Harvard Art Department. It has been treated fully and attractively by Professor E. W. Forbes. But here may be the place to review Moore's academic career briefly.

In 1871 he had been appointed Instructor in Freehand Drawing in the Lawrence Scientific School. In 1874 he was transferred at the same grade to the College. Preparing himself for his new work with Norton in the Academic department, he was absent on leave in Europe for most of 1876 and 1877.

Moore returned to Cambridge in 1878. In 1890 he was to receive the well-earned honorary degree of A.M. from Harvard. He was promoted to an assistant professorship in 1891, to a full professorship to which was added the directorate of the Fogg

Museum, in 1896. His ascent of the academic ladder had been entirely normal, if anything, slow. But these years of apparent routine were years of affliction, reconstruction and dawning of new interests.

On January 11, 1880, his wife died. With a cultivation equal to his own, and unusual gifts of character, she had been an ideal helpmate through their fifteen years together. On her death Moore wrote a beautiful tribute to her, most of which I quote from a copy kindly sent me by his daughter.

"On Sunday January 11th 1880 at about 11 A.M. the spirit of my blessed wife left the dear material body.

"Our married life has been one of unbroken and unspeakable happiness, and my greatest happiness now is in anticipation of our reunion in the other world when our Heavenly Father wills it."

For two years he remained a widower and then on December 30, 1881, married Elizabeth Fish Hewins.

He had always been a devout person and deeply interested in Swedenborgianism, but, believing Swedenborg never meant to found a church, he often attended but never joined the Church of the New Jerusalem. Indeed he seems to have had no formal church membership until in his early fifties; on February 28, 1892, he was confirmed as an Episcopalian in St. John's Memorial Chapel, Cambridge, by Bishop Phillips Brooks. In religion as in other matters Moore moved slowly but unhesitatingly toward his goal. He seems to have been spared the doubts and denials that were the often tragic lot of the more thoughtful men of his generation.

Professionally the important change in his interests was his concentration on architecture, especially that of the Middle Ages. In the Houghton Library is a letter of Moore's to Norton from Senlis, dated August 2, 1885, which reveals Moore's new orientation. In it he discusses problems of structure, offers, with a sketch of the tympanum, appreciations of the sculpture—in general anticipates the functional point of view which was to distinguish his future famous books.

But the concentration on architecture had probably been long preparing. Over twenty years before the Senlis letter, Moore had had the comradeship of two fellow Pre-Raphaelites who were good architects, P.B. Wight and Russell Sturgis. Wight, who designed the building of the National Academy and the Yale Art Gallery, put Ruskin's teaching into successful practice. Sturgis was soon

diverted from designing to the acquisition of encyclopaedic knowledge of the history of architecture. In *The New Path* he had written much and ably on Romanesque and Gothic architecture. Moore's mentor, Norton, was profoundly concerned with architecture, and in 1880 took the pains to translate and popularize the abundant and instructive records of the Cathedral builders of Siena—*Historical Studies of Church Building in the Middle Ages.* And of course for Moore to have been about Venice for months with John Ruskin was to have learned and felt much about an enchanting aspect of Gothic architecture. It was characteristic of Moore's centrality that while profiting by Norton's historical and Ruskin's esthetic approach, he put himself solidly in the succession of Viollet-le-Duc's functionalism.

Parenthetically, the reader is referred to the preceding chapter in which I have treated Moore's five mezzotints of 1880, his last attempt to sell his work. In the early 1880's he sought an extension of his and also Ruskin's method of teaching drawing by publishing two books for school children and amateurs. These contained, with instructions for use, fine examples of details by great artists, and Moore's own admirable copies of details from painting and architecture. In 1882 was published *Facsimiles or Examples in Delineation Selected from the Masters for the Use of the Student in Drawing* (Cambridge: Moses King, Publisher). This consisted largely of details by the new Forbes process, of drawings by Holbein and woodcuts after Dürer. It was an attempt at broad popularization. There followed in 1883 an album more specifically directed toward the primary schools, which then as now gave a generally perfunctory training in drawing. It was made up largely of Moore's beautiful copies of details scattered several on one plate. The abridged title is *Examples for Elementary Practice in Delineation . . . for the Use of Schools* (Boston and New York: Houghton Mifflin Co., 1883-84). The few school children or amateurs whose first use of the pencil was inspired and guided by these albums were lucky indeed. But since there is no trace of a second edition of either book, we must fear that Moore's only evangelical efforts failed to attract the attention they well deserved.

While my purpose is rather to record Moore's activities than to limn his portrait, I feel the reader may welcome a sketch combining recollections of early acquaintance with those of his

daughter and of Mr. Martin Mower, for years his chief assistant. So close was Moore's relation with the latter that the students spoke of them as a firm—Moore & Mower.

In the Yard and lecture room Moore was an impressive and somewhat exotic figure. Erect, vigorous, he was marked by his prematurely white hair and beard, as by his British tweeds, his habitual wear at a time when most Harvard professors still donned, almost as a uniform, the traditional, black frock coat.

He was a notable talker, if a somewhat dominating one, by the weight of his substance and the charm of his voice. He moved little in general society, but loved small and congenial gatherings, especially about the dinner table. There he was an acknowledged authority on cuisine and wine cellar.

Socially he was an unsparing foe of anything like affectation or pretense. His weapon against these bothers was rather a broad and genial humor than a rapier wit. Here, it may be remarked, that though he was a great reader outside his specialty, his interest in the drama was slight and casual, always excepting Negro minstrel shows, then still flourishing, and the annual burlesques given by the Hasty Pudding Club. One may reasonably imagine that his prestige, in which admiration was tempered by a shade of awe, was much like that of his future colleague Professor Kittredge. Kittredge, however, had the knack of evoking competent student Boswells, while for Moore we have little more than such a composite of the testimony of his friends as I have hesitantly attempted.

CHAPTER X

Moore's Architectural Studies.
Museum Director

In 1890, being fifty years old, Moore published his epoch-making book *The Development and Character of Gothic Architecture*. It was an overdue slap in the face to a century of sentimental critics and tourists. It held there were no notable Gothic buildings outside the Ile-de-France; it relegated to a category of "Pointed Architecture" hundreds of well-loved buildings in England, France, Italy, Germany and Spain, which had been admired as Gothic masterpieces. Earlier critics had accepted the pointed arch as the broad criterion for Gothic. Some, especially the very popular and persuasive John Ruskin, had found the characteristic beauty of Gothic in its lovely naturalistic ornament, as contrasted with the generally geometric ornament of the Romanesque.

These two criteria Moore swept away with a ruthless logic, as superficial. Most buildings with pointed arches differed in no structural way from their Romanesque predecessors, were dead-weight buildings. A really Gothic structure concentrated the weights and thrusts on a few points of support, where weight and thrust were beautifully and ingeniously taken care of by vaulting ribs, clustered columns, flying buttresses, etc. Gothic weight was live weight, active weight. Gothic structure was not static but dynamic.

In this doctrine there was little absolutely new. Viollet-le-Duc held a very similar position. But no one before Moore had carried the dogma of functionalism to its logical conclusion, had made the exclusions—often painful exclusions—that it required. To lovers of the Gothic tradition, as it had been understood, or misunderstood, Moore seemed a ruthless iconoclast, a foe of generous enthusiasm. Professional architects, while often differing in details, appreciated the tonic thoroughness of Moore's arguments. He was soon awarded honorary membership in the best professional societies of British and American architects—the Royal Institute of Architects, the American Institute of Architects.

Moore had passed from a local reputation as a sort of super drawing-master, to international fame, as one of the major critics of architecture.

Before leaving this book, a word on the illustrations. These were beautiful pen drawings, mostly by Moore's own hand. A number of the line drawings were contributed by his daughter Elizabeth. All these illustrations were in the tradition of Viollet-le-Duc. Such drawings tell more and better the significant facts of structure than does any photographic reproduction, and are a boon alike to the professional architect and to the studious layman. Moore had conducted what was really a campaign for the better understanding of Gothic with the most intelligent and painstaking generalship. A second and much revised edition of what had become a classic book was published in 1899.

The task of writing his great work on Gothic architecture—which by 1888 was already prepared for publication—had evidently released the always latent man of letters in Moore. This is attested by a group of letters, preserved in the Houghton Library, addressed to Horace E. Scudder, the versatile and perceptive editor of *The Atlantic Monthly*, and a close friend of the Moores. Scudder had suggested publishing an advance chapter of Moore's impending book. Norton, to whom the proposal was referred, must have disapproved, for the *Atlantic* made no such advance publication.

About a year later, September 3, 1889, Moore submitted to Scudder an article on "Materials for Landscape Art in America." It was published, with slight revisions offered by Scudder, in the *Atlantic* for December 1891. Agreeable enough reading, it hardly shows Moore at his best. He dismisses, tactfully withholding names, American landscape painting as defective, lacking in insight. But already Inness had painted his noblest landscapes; Homer D. Martin had nearly finished his career; Wyant was still painting; Winslow Homer, a fine landscapist, if only episodically, was in his prime; Ryder surely in his fantastic way an important landscapist, had painted all but three or four of his really great pictures. The situation was better than it seemed to Moore.

To me his judgment seems disabled by his perfectionism. He felt that certain subjects, and only these, were inherently beauti-

ful, hence paintable. It is a curious reversion to the old doctrine of *belle nature*, a belated academic position.

One welcomes Moore's tribute to the unique loveliness of some of our American trees, when isolated, but wonders if he had seen the silvery stateliness of the sycamores of the Delaware valley. One accepts regretfully his elimination of the New England farmhouse as painter material, but winces at finding the churches and villages of New England swept aside in a couple of sentences. I am Connecticut-born and Massachusetts-bred, so I resent the cancellation from a landscapist's repertory of Old Deerfield, Suffield, Stockbridge and Woodstock. It is pleasanter to recall Moore's praise of the Leeds five-arched bridge, an old love to which he was ever faithful. Nearly twenty-five years earlier he had tipped off its charms to Norton.

Since in many later essays for magazines Moore was never again of so schoolmasterly a mood, one may guess that in his first appearance in the deeply respected *Atlantic*, he felt it his duty to pontificate.

Scudder, pleased enough with the article, or else perhaps shrewdly banking on the effect of Moore's great book on Gothic architecture, either already published or about to be, pressed him for other contributions. In a letter of July 17, 1890, sent from Boxford, Moore expresses willingness, but also pleads heavy pressure of work. He was too busy at encyclopaedic work for "Mr. Longfellow" to make serious commitments for the *Atlantic*. He was contributing articles to William P. Longfellow's *Cyclopedia of Works of Architecture in Italy, Greece and the Levant*, which was published by Scribner's in 1895. Mr. Longfellow, a nephew of the poet, was a distinguished architect and author of several books on architecture which are still serviceable. For Moore the task must have been a sort of high-class, friendly hack-work, for it lay entirely outside his favorite field, Gothic architecture in France. It is probably impossible and perhaps unnecessary to identify Moore's contributions to this *Cyclopedia*, since the preface does not mention him, and none of the few initialed articles bear his initials.

But, Moore goes on, " 'Pre-Raphaelitism and Impressionism as Opposite Extremes of Modern Realism' is a subject that I should like to say something about. I should try to show that both are partial in the qualities which they seek—the one ignoring breadth,

and the other ignoring form." A magazine which like the *Atlantic* excludes illustrations, has to be very chary of accepting articles on art. So the proposed contrast between Pre-Raphaelitism and Impressionism came down to a paragraph in a later article on "The Modern Art of Painting in France," which was published in the *Atlantic* for December 1891.

Upon this generally excellent essay I shall not dwell, for I am sure that in no distant future a selection of Moore's best magazine articles will be published. There will be surprises in it— Moore's splendid tribute to Watteau, of whom in general he disapproved, as a consummate colorist. The essay dates, but not too badly. He dismisses Claude, whom his own mentor Ruskin had demolished, barely mentions Poussin, finds David entirely devoid of merit, regards Constable as a minor figure, virtually ignores, with fine impartiality, Ingres and Delacroix. Here the essay is a good document for our best academic taste of its moment, and valuable as such.

On the credit side are a scathing analysis of the narrowness of the Beaux-Arts training, good advice to young American painters to learn their elements at home, finally his opinion that the new Impressionists, rather than undertake their empirical and pseudo-scientific experiments, would have done better to study and assimilate the technique of such great Venetians as Titian and Veronese.

Though not illustrated, the article was eminently available for the *Atlantic*, since Corot, Millet, Courbet and Monet were fighting names among our American painters and critics, while various French paintings, including many of the Barbizon School, were generously accessible to readers of the *Atlantic* in Boston, and reasonably accessible to readers in New York and Baltimore. Throughout the essay the truth is reiterated that the problem of the painter is largely spiritual and only in part technical. Moore published only one more article, perhaps his best, in the *Atlantic*— "John Ruskin as an Art Critic," analyzed later in this chapter.

The letters from Scudder to Moore have been especially fascinating to me since through them I glimpse the sagacious and benign figure of one who was a sort of guardian angel to me when, in my salad days as a man of letters, I was making a hesitating transition from the pages of the *William Literary Monthly* to those of the *Atlantic*. I understand perfectly why when Moore

had ended a letter with conventional "kindest regards," his young daughter, Bessie, already his collaborator in the illustration of his first and best book, insisted that this line be added—"Bessie tells me that I ought to have sent her *love*."

In 1895 the Fogg Museum of Art was built, and Moore after a brief term as curator was appointed director. This attractive Renaissance building, opening hospitably on Massachusetts Avenue, had been designed, as is too often the case, without consulting its users, or more than casually its use. Accordingly it was from the outset something of a misfit. The acoustics of the big lecture hall were the worst; the small galleries, unimpressive. Still it made possible the recall of the Gray and Randall collections of prints from the Boston Museum, and a reasonable exhibition of the rarer examples, as well as of the best drawings and water-colors in Moore's teaching apparatus, also of additions thereto. There was room enough for the classes, room for the beginnings of a special library on the fine arts.

A Greek marble torso of fine quality, and a group of Greek vases were new and notable acquisitions. Yet, from the time when I was an early and reverent visitor, my abiding impression has been of a monster vitrine in which were exhibited authentic examples of the shoes of the ages, the donors of the building having made their money in shoe manufacturing. This archaeologically valuable collection is doubtless still available to students in the basement of the present Fogg Museum. Whatever its defects, the building much improved the status of the Art Department, giving it the dignity of a householder in the Yard, where for twenty years it had had only scattered lodgings in buildings devoted to general purposes.

As I recall frequent visits to this Museum, it is a deep regret that I never looked up the director, of whose book I had been an admiring reader; but I was then a young professor of modern languages, without standing of any sort in the art world, withal abnormally shy about imposing myself on celebrities.

From about 1900 on, the Fogg Museum began to assume a new importance through loans which later became gifts, from a young alumnus, Edward Waldo Forbes. As an undergraduate he had been a student not of art but of literature. But he had a native love and gift for painting, predilections which had doubt-less been encouraged by the pervasive influence of Norton. Travel-

ing in Italy, he began to collect fine primitive panels, mostly of the Sienese and Umbrian schools, with the help of resident American experts, Bernard Berenson, F. Mason Perkins, and Richard Norton. Forbes was a talented amateur painter, and later took over in a more archaeological sense some of the practical work which had been begun by Moore. Eventually, in the year after Moore's retirement, his name was to appear in the Harvard Catalogue as an instructor conducting a course on "Problems of Early Florentine Painting." Forbes, for his study on the technique of painting, and for his discriminating gifts to the Fogg Museum, was obviously already in line for the directorate whenever Moore, who was reaching the usual age of retirement, should resign.

Moore had added the directorate, in itself no sinecure for a man of his disposition, to duties already heavy. Yet he began new books, and wrote occasionally for the magazines. Notable is his essay, mentioned previously, "John Ruskin as an Art Critic," which was published in *The Atlantic Monthly* (LXXXVI [October, 1900], 438-450). Considering that Ruskin had been both a preceptor and an intimate friend, Moore's objectivity and detachment are amazing. He drops no hint that he ever knew Ruskin personally. He reveals explicitly the cardinal defects of Ruskin's temperament. He finds Ruskin's greatness in his grasp of larger values in art, in his devout and penetrating study of natural appearances. Moore writes with admiration of Ruskin's skill as an artist, but merely mentions in passing, perhaps as obvious, Ruskin's greatness as a stylist. In general, with every temptation to divagate, Moore sticks closely to the business announced in his title, and as a result he gives perhaps the most discriminating analysis in existence of Ruskin's qualities and defects as a critic. Some day there will be a collection of Moore's scattered or unpublished essays. In such a miscellany the essay on Ruskin will be a major feature.

Moore published in 1905 his second important book, *The Character of Renaissance Architecture*. The subject invited no such novelty of approach, nor yet such severely logical treatment as had distinguished its predecessor, for Renaissance architecture lacked constructional logic, and had been thoroughly bewritten. So it remained for Moore merely to emphasize the superficiality or absence of organic design, and to admit the incidental charm of much that he could not approve. The book still is valuable for

its unwavering consistency, for its exemplary clarity and orderliness, but a discriminating reader will accompany its perusal with that of Geoffrey Scott's *The Architecture of Humanism.*

As he approached seventy, Moore hardly seemed to himself or to others an old man. Photographs of him at this time show an apparently alert and vigorous man well along in his sixties with beautiful white hair and beard. A good physiognomist would have predicted many years of activity for Moore, as turned out to be the case.

But such activities were to be conducted not in Cambridge but in England, for President Eliot, always forward-looking, and approaching retirement himself, wished to leave the growing Art Department in younger hands.

Moore, as his various duties grew heavier, had gradually enlisted a new teaching staff of talented youngsters—notably George Chase, Arthur Pope, Chandler Post—thus assuring the continuity of the work that he and Norton had established. Now Eliot suggested that Moore, who had reached the usual age of retirement, should resign. A notable bridge-burner in the past, now was Moore's moment to burn his last bridge, especially as he had long desired to retire to England. He therefore decided on passing his old age in that country, and actually sailed thither in midsummer of 1909.

This radical flight, while it involved breaking many cherished habits, probably was not tragic on the personal side. His best friend among his seniors, Norton, was gone. So were that most delightful of couples, the George Palmers, Moore's neighbors both in Cambridge and the Boxfords. His younger associates held him in profound respect rather than in warm friendship, though their affection and regard for him were shown on his retirement when they joined with other friends and former pupils in presenting to the Fogg Museum in his honor two fine watercolors by Ruskin. On the whole, however, there were fewer and slighter bonds to be broken than is usual after a residence of nearly forty years.

England was his logical choice for his new home. Since his memorable studies with Ruskin over thirty years past, Moore had been a convinced Anglophile. England had remained a spiritual home for him. On a lower plane of decision, the memory of temperate English summers must have allured a man who suffered

intensely from the merciless heat of our New England summers. Professionally, too, England was indicated. Moore must have been planning his last important book, *The Mediaeval Church Architecture of England*.

To prepare for the move to England was no slight matter. There was a house at Cambridge and another at Boxford to be cleared for sale; the accumulations of some forty years as an artist and scholar had to be dealt with—a job of selection, packing and transportation of the most complicated difficulty. Moore accomplished it in a few months. The Moores sailed for England and new fortunes on August 10, 1909.

He took along a rigorous selection from his work as a painter and etcher; nothing earlier than his Pre-Raphaelite period. Here he kept a few of his amazing line drawings of the late 1860's, and the watercolor of a snow squall (Fig. 14), perhaps his finest painting. From his early Cambridge and his European years he kept the watercolor "Sawmill at West Boxford" (Fig. 28), and the best of the Italian watercolors made to be mezzotinted, "On the Lagune" and "Storm Clouds over Simplon Village" (Fig. 31). He kept also the unsold remnant of the mezzotints—because he especially valued them, or in the hope of selling them. There were no oil paintings of importance.

CHAPTER XI

Home at "Wellfield."
Book on English Church Architecture.
Critical Articles.
Last Days

To ESTABLISH a new home in England took a year or so. In family letters one finds the Moores at Bournemouth, Malvern and London. Much of this year must have been spent in studying English cathedrals and churches for his next book. His daughter Bessie went with him on these trips helping in the measuring, preparing for the illustrations.

His fellow members of the Royal Institute of British Architects looked him up, and solicited his contributions to their *Journal*. The obscure young drawing master who thirty-four years earlier had come to England in order to become a disciple of Ruskin now returned to England with an international reputation as a critic and historian of Mediaeval and Renaissance architecture.

The Moores finally settled on their pleasant hilltop site at Hartley Wintney in Hampshire on the advice of their friend Miss Rose Kingsley, the daughter of the famous author Charles Kingsley. They bought a plot locally called "Wellfield" and accepted the name for the country house that Moore designed and built. Nearby on the same ridge was the fine old church of St. Mary. The pilgrim road to Canterbury passed within a few miles. Eversley Church beside which Charles Kingsley was buried was a short walk away. All the gentler and ingratiating charms of English landscape were Moore's for a look out of his window.

Moore's last important book on architecture, *The Mediaeval Church Architecture of England*, appeared in 1912. This elaborate and comprehensive study must have been his main occupation during the first two years in England. There must have been much reading, much visiting and revisiting the churches. His general criticism of the design and construction had been made

trenchantly in his first book. He did not need to repeat ungraciously this generally unfavorable critique, was free to admit the charm of the cathedral closes, the modest fitness of parish churches, the richness and variety of English ornament. It is a book along familiar descriptive and appreciative lines, and as such is still useful after so many years. Virtually all the beautifully precise linear drawings of structural details are from the skilled hand of his daughter Elizabeth.

How Charles Moore passed his old age in his English pleasure house a biographer may merely imagine. The usual benign falling-off in strength was solaced in his case by the comradeship of his wife and by that of his daughter who had inherited his tastes and much of his talent. Harvard friends had mostly passed away, but there was a correspondence to maintain with his dearly beloved sister Virginia. He wrote occasionally for the *Journal of the Royal Institute of British Architects*, notably an article on "Romanesque Architecture" in 1913, and one on "The Study of Mediaeval Architecture" in 1915, in which he characteristically emphasized the functional approach as central.

From boyhood Moore had been fascinated by the revelations of Swedenborg. They had inspired his mother. As a young man Moore as naturally wrote to her about his reading of Swedenborg's books as a modern youth would write about his sports. So it was entirely fitting that Moore's latest work should be the useful little pamphlet of 1918, *Swedenborg, Servant of God*. It is one of the best introductions to its large theme, being written with more enthusiasm than the encyclopaedic articles of similar scope.

Until Moore, in 1921, reached his eighty-second year, his energy remained amazing. In addition to his important book on *The Mediaeval Church Architecture of England*, he published no less than nine articles in the American *Architectural Record* and the *Journal of the Royal Institute of British Architects*. These articles dealt generally with fundamentals and principles. They still retain their value, and should some day be collected. And it should be recalled that for a writer of Moore's thoroughness a magazine article was never thrown off with journalistic facility. It was a serious task, involving much time and thought.

This sustained production of his eighties continued to the end. In 1922 he published no less than three important articles in the

Architectural Record, and in 1924 an article on "Ruskin as a Critic of Architecture." It is a singularly objective, even an unsparing performance, considering that John Ruskin had been Moore's friend and mentor, but it was consonant with that outspoken frankness which Moore used to all his colleagues, and expected them to use toward himself.

Moore was now a very old man. Naturally his physical strength was becoming pretty well exhausted. He had the usual disabilities, which he bore with resignation and fortitude. His mind was clear to the end, and his interests well maintained. His was on the whole a benign afterglow. His daughter kindly writes me:

"His interests remained to the end, and a considerable amount of zest. Four days before he died he read with keen attention the report of an important debate that was going on in the House of Lords. He took great pleasure in our beautiful and extensive view, which from the large windows of his great bedroom is magnificent, and he enjoyed this lovely countryside, and we had pleasant friends and acquaintances. He read books on history, science and other subjects, and enjoyed such a book as Gilbert White's *Natural History of Selborne.*

"He was up and dressed even on the last day of his life. In the afternoon he fell unconscious and passed peacefully away." This was on February 15, 1930. In two months Moore would have been ninety years old.

Charles Moore's was a soul naturally Christian. He was a Christian for many years before in middle life he became formally an Episcopalian. While reading the Bible some months before his death, he pointed out to his daughter the text "I know that my Redeemer liveth," and said "some day that may be useful." It is carved on his headstone in the cemetery of the old Norman church of St. Mary close to "Wellfield."

This little book was written to explore as thoroughly as possible Charles Herbert Moore's early career as a professional artist and to offer such appreciation of his works as seemed indicated by what were really discoveries. Everything else in this book is merely incidental. So it is beyond my scope to make a complete estimate of Charles Herbert Moore as a man. The materials for such an estimate lie, I think, before the reader, who is surely capable of making his own estimate. In closing, I cannot refrain

from quoting in part two far from formal tributes. The first is from a notable English colleague in the study of mediaeval art and architecture; the second is the resolution written for the faculty of Harvard University by three younger colleagues, two of whom had been his pupils.

On Moore's death his friend, the distinguished mediaevalist, W. R. Lethaby, wrote in the *Journal of the Royal Institute of British Architects*:

"For myself I owe him much. He was a man of remarkable force, of high honour, wide culture and the most considerate courtesy. Almost more than anyone else whom I have known; he carried on the older, greater spirit of the Victorian Age."

This appreciation by an English contemporary is confirmed by that of three young colleagues at Harvard, Professors George Chase, Arthur Pope, and Chandler Post. I quote the last paragraph of the resolution they drafted for the Harvard faculty:

"The keynote of Professor Moore's character was his hatred of sham. In art, as in life, he demanded above all things honesty and simplicity. It was this quality which attracted him to the mediaeval architecture of France and to the earlier rather than the later painters of the Italian Renaissance, and it was this quality that endeared him to many students, especially to those who worked with him in small and intimate courses. To his students he will always remain the embodiment of that simplicity and courtesy which are involved in the ideal of a scholar and a gentleman."

As I finished what was to be my last page, by way of celebration I turned to the final pages of André Gide's *Journal*. There I happened on an aphorism which seemed to supplement the appreciations above. On February 1, 1938, Gide wrote: "He who exacts much of himself is naturally inclined to exact much of others." (*"Celui qui exige beaucoup de lui-même se sent naturellement porté à beaucoup exiger d'autrui."*)

It is precisely this exacting quality of Moore's personality which tended to create among some of his pupils and contemporaries an impression of a man of undue austerity. Seen in retrospect, however, this quality appears rather the key to the development of one whose character was so consistent and well-rounded as was that of Charles Herbert Moore.

APPENDICES

1. A Note on Manuscript Sources, Prepared by Frank Jewett Mather, Jr.

THROUGH THE KINDNESS of Moore's niece, Mrs. Theodore Krueger, of Putney, Stratford, Connecticut, I have had access to family letters touching Moore's activity from his thirteenth year almost to his death. Mrs. Krueger has not only shown me these letters but has patiently searched them for information which might be useful to me. I owe her a debt of gratitude which is not easily expressed.

A group of Moore's letters to Charles Eliot Norton are an invaluable source for Moore's ideals and activities in his Pre-Raphaelite period. They were given by Miss Elizabeth Huntington Moore to the New York State Museum, Albany, N.Y., and are here quoted by permission of Miss Moore and the Museum.

In the Charles Eliot Norton Collection of the Houghton Library at Harvard are a number of letters by or to Moore, which I have freely drawn upon with the permission of that Library and of Miss Elizabeth Norton. Among them is Moore's correspondence with Horace E. Scudder, editor of *The Atlantic Monthly*. In my possession are many letters from Miss Elizabeth Huntington Moore to me. Miss Moore has clear memories of her father's career from his first European trip to his death.* Her letters have done much to lend substance to what otherwise must have been a leaner book.

At my suggestion Miss Moore has given to the Houghton Library, Harvard, thirteen typewritten articles by her father of about 6,000 words each. These typescripts are in immaculate condition. They have not been sent around by post nor served as printers' copy. I believe they are all carefully prepared lectures. Had they been read many times before classes, the considerable wear and tear and revision involved in such use would be evident. One may safely imagine that with characteristic conscientiousness Moore memorized these lectures, even such as were given informally to small classes.†

* EDITOR'S NOTE: Miss Moore, who outlived Frank Jewett Mather, Jr., died in England on April 22, 1956.
† EDITOR'S NOTE: In regard to these typescripts, see also Chapter IX.

Six were pretty surely written for FINE ARTS 4 when Moore took over this famous course on Norton's resignation. These are:

1. Ancient Painting
2. Mediaeval Painting
3. Mediaeval Painting (draft)
4. Venetian Painting (This probably offers the substance of the article which Moore prepared for *The Nation* in 1876.)
5. The Rise of Landscape Painting
6. Pre-Raphaelitism

The following six were delivered to his classes following the "laboratory method":

7. Perspective
8. Chiaroscuro (iii)
9. Tone, Mystery, Breadth and Finish
10. Qualities Growing out of Processes and Materials
11. Composition
12. Color
13. Romanesque Architecture

I believe all this material should be printed, especially the fine observations on picture making in numbers 7 to 12.

2. Editor's Note on the Chief Collections
of Moore's Work as Artist

FRANK JEWETT MATHER, JR.'s interest in Moore—which led
him to acquire several works by the artist and also attracted
generous gifts from Moore's daughter, Miss Elizabeth Hunting-
ton Moore—has made the Art Museum, Princeton University,
one of the two chief repositories of his work. At present the Mu-
seum's collection includes five paintings in oil (one of them,
"Winter Landscape," acquired by Dr. Mather after he finished
the manuscript for this book), thirteen watercolors, three draw-
ings, and fifteen prints by Moore. The other chief collection, that
of the Fogg Art Museum, Harvard University, contains no less
than eighty-one watercolors, twenty-eight drawings, and nine
prints. Most of the watercolors and drawings at the Fogg Museum
were transferred from the Fine Arts Department, and deposited
at the Museum by Moore himself. The remaining works, given by
various individuals, include several presented by the daughters of
Charles Eliot Norton. On loan at the Fogg is also the oil portrait
of Ruskin owned by Professor Paul Sachs.

INDEX

Allen, George, 53f.
Allston, Washington, 18, 20
Angelico, Fra, 30, 58
Associates of the National Academy, 16

Beard, William H., 20
Bellini, Gentile, 58
Berendtson, Jane Maria, 3
Berenson, Bernard, 69
Bierstadt, Albert, 20, 43
Botticelli, Sandro, 58
Boudin, Eugène, 13
Brooks, Alfred M., xiiif., 32
Brooks, Phillips, 61
Brown, John G., 20
Bryan, Thomas J., 7
Burne-Jones, Edward, 58

Carpaccio, Vittore, 30, 48f., 58
Chase, George, 70, 75
Church, Frederick E., 5, 7, 9, 13, 17, 21, 43
Churchill, Winston, 14
Clark, Rosamund, xiv, 40
Claude Lorrain, 35, 67
Coe, Benjamin H., 4ff., 10f.
Cole, Thomas, 5, 7, 11, 18, 20, 23, 43, see also Thomas Cole Studios
Constable, John, 14, 67
Cook, Clarence, 18f.
Corot, Jean B. C., 7f., 21, 32, 67
Cotman, John S., 13
Courbet, Gustave, 67
Cropsey, Jasper F., 7, 17
Currier and Ives, 9, 25

Daubigny, Charles F., 32
David, Louis, 67
Delacroix, Eugène, 67
Diaz de la Peña, Narcisse, 21
Dickason, David H., 17n
Durand, Asher B., 5, 7, 9, 13, 17f., 20
Dürer, Albrecht, 62
Durrie, George H., 25

Eliot, Charles W., 45, 47, 57, 70
Eyck, Jan van, 36

Farrer, Henry, 17, 20, 32
Farrer, Thomas C., 17, 20, 32
Fogg Museum of Art, built, 68
Forbes, Edward W., 60, 68f.
Force, Mrs. Juliana, xiii, 27

Gaillard, Ferdinand, 35
Gallatin, Albert, 31
Gellée, Claude, see Claude Lorrain
Gérôme, Jean L., 21
Gide, André, 75
Gilman, W. C., 37
Giotto di Bondone, 30
Godwin, A., 58
Goethe, Johann Wolfgang von, 33

Hamerton, Philip G., 31
Harvard Laboratory Method, 57
Haskell, Ernest, 31, 34
Hennessey, William J., 21
Hewins, Elizabeth F., 61
Hill, John H., 19, 32
Hill, John W., 19, 32
Holbein, Hans (the Younger), 62
Homer, Winslow, 10, 21, 25, 31, 50f., 65
Hosmer, Harriet, 20
Hudson and Smith, 5
Hudson River School, 15, 21
"Hundred Guilder Print," 36
Hunt, Holman, 29
Hunt, William M., 4, 20f.
Huntington, Daniel, 20

Ingres, Jean A. D., 67
Inness, George, ix, 8, 10, 14, 20, 41, 43, 65

Jacque, Charles E., 32
James, Henry, 4
James, William, 4
Jarves, James J., 21
Johnson, Eastman, 21
Jongkind, Johan B., 13
Jourdain, M., 31

Kensett, John F., 7, 14, 21
Kingsley, Charles, 72
Kingsley, Rose, 72
Kittredge, George L., 63
Krueger, Mrs. Theodore, xiv, 5, 37, 79

La Farge, John, 4, 8, 10, 13
La Touche, Rosie, 49
Lethaby, William R., 75
Leutze, Emanuel, 20
Lippi, Filippino, 58

Longfellow, Henry W., 18
Longfellow, William P., 66

McEntee, Jervis, 7
Malbone, Edward G., 18
Marin, John, 25, 51
Martin, Homer D., ix, 8, 10, 14f., 20, 41, 65
Mignot, Louis R., 25
Millet, Jean F., 21, 32, 67
Monet, Claude, 67
Moore, Charles, 3, 6
Moore, Charles Herbert
 Associate of National Academy 16; at Hartley-Wintney 72; at Harvard 48ff., 60 (and Lawrence Scientific School) 42, 44f., 60; at North Conway, N.H. 37f.; at Simplon Village 39, 50f.; birth 3; chief repositories of his work 81; contributions to *The New Path* 21f.; courses at Harvard 57ff.; death 74; death of his first wife 61; education 3f.; in business 5ff., 10, 23; in Florence 50; letters and lectures 11, 16f., 24ff., 42, 45, 48ff., 53, 57ff., 65f., 68, 72f., 79; marriage 16, 23; member of R.I.B.A. and A.I.A. 64, 72; move to Cambridge, Mass. 44; move to Catskill, N.Y. 16, 23; physical appearance 63, 70, 74; relations with Ruskin 49; religion 3, 61, 74; résumé of academic career 60f.; retirement in England 70-74; sails for England on leave of absence 48; second marriage 61; summer home at Boxford, Mass. 46, 66, 71; to be on Vassar faculty 11; tributes from colleagues 74f.
 Works of art: "Autumn in the Mountains" 15; "Catalogue with Notes of Studies and Facsimiles ..." 58; "Catskill Bywater" 10; "The Catskills in Spring" 9, 13f.; "Cedar Tree" 20; "Down the Hudson to West Point" 13; "Early Evening on the Housatonic" 9; "Hudson River above Catskill" 24; "In Berkshire County" 8, 33; "John Ruskin" 52; "Landscape" 40; "Ledge and Spruces" 32; "Leeds Bridge" 16, 27, 29, 35, 39, 41; "A Mandrake" 20; "Morning over New York" 14; "Mount Kearsarge" 40, 47; "Mount Washington" (pencil drawing) 17; "Mount Washington" (watercolor) 39; "Mount Washington" (watercolor, unfinished) 39f.; "Near Great Barrington, Mass." 15; "Near Simplon Village" 50; "October Snow Squall" 25, 33; "The Old Doorway, Venice" 55; "On the Lagune" 55, 71; "Over Mountain Shoulders" 33; "Overgrown Wood Road" 32; "River View with Cattle" 8; "Rocks by the Water" 40; "Sawmill at West Boxford" 46f., 71; "Schooners, Ironbound Island, Maine" 45; "Simplon Village" 51f.; "Snow Squall" 29, 71; "Storm Clouds over Simplon Village" 51, 71; "Upland Pasture" 28; "The Upper Palisades" 12f.; "The Valley of the Catskill from Jefferson Hill" 25, 34f., 39; "Venetian Doorway" 50; "Water Mill, Simplon Village" 51; "White Mountain Country" 37f.; "White Mountains" 38; "White Mountains, Autumn" 37, 39; "Winter Landscape, Valley of the Catskill" 27, 81; "A Winter Study in the Catskills" 28
 Writings: (books) *The Character of Renaissance Architecture* 69; *The Development and Character of Gothic Architecture* 64; *Examples for Elementary Practice in Delineation ...* 62; *Facsimiles or Examples in Delineation ...* 62; *The Mediaeval Church Architecture of England* 71ff.; (magazine articles) "Fallacies of the Present School" 21; "John Ruskin as an Art Critic" 46, 53, 67, 69; "Materials for Landscape Art in America" 65; "The Modern Art of Painting in France" 67; "Pre-Raphaelite Movement" 46; "Romanesque Architecture" 73; "Ruskin as a Critic of Architecture" 74; "The Study of Mediaeval Architecture" 73; "Venetian Painting" 46; (pamphlet) *Swedenborg, Servant of God* 73
Moore, Elizabeth H., xiiff., 3, 23, 25, 31, 35, 39f., 45f., 48f., 65, 68, 72f., 79, 81
Moore, Herbert, 3
Moore, Howard L., xii, 5
Moore, Lucy, 17
Moore, Virginia, 73
Moore family, at New York City 3; at Putney, Stratford, Conn. 6f., 10
Morse, Samuel F. B., 18
Mowrer, Martin, 59, 63

National Academy exhibitions: *1846*, 4; *1858*, 7, 11, 16; *1859*, xii, 8f., 15f.; *1860*, 16; *1865*, 16, 28; *1867*, 16, 24f., 28, 33; *1870*, 16, 28; *1872*, 37
Neagle, John, 18

New Path, The, 18ff., 28, 46, 53, 62
Norton, Charles Eliot, 11, 23f., 26ff., 42ff., 47ff., 53ff., 57ff., 65f., 68, 70, 79ff.
Norton, Elizabeth, xiv, 50, 79
Norton, Richard, 69

Palmer, Erastus D., 20
Palmer, George, 70
Parmelee, Elmer E., 5f.
Parton, Arthur, 21
Perkins, F. Mason, 69
Phelps, Mrs. Frank Van R., xii, 8f.
Photographs of Studies from Nature, 20, 31
Pope, Arthur, 40, 45, 57, 59, 70, 75
Post, Chandler R., 70, 75
Potter, Bishop Horatio, 23
Poussin, Nicolas, 30, 67
Powers, Hiram, 20
Prout, Samuel, 58

Raphael, 20
Reed, Luman, 7
Robinson, Edward, 59
Rossetti, Dante Gabriel, 24
Rousseau, Théodore, 21, 32
Ruskin, John, 4ff., 10f., 13, 17, 19f., 22f., 26f., 30, 34f., 45ff., 50ff., 55, 58, 61f., 64, 67, 69f., 72, 74, 81
Ruysdael, Jakob van, 33
Ryder, Albert P., 65

Sachs, Paul J., 53, 81
St. George's Guild, 50
Scott, Geoffrey, 70
Scudder, Horace E., 65ff., 79

Shaler, Nathaniel S., 57
Society for the Advancement of Truth in Art, The, 18, 22f.
Stieglitz, Alfred, 40
Stillman, William J., 17
Stuart, Gilbert, 18
Stuart, Robert L., 7f.; collection xii
Sturgis, Russell, Jr., 18f., 61f.
Sully, Thomas, 18
Swedenborg, Emanuel, 3, 61, 73

Thomas Cole Studios, ix, xii, 29
Thompson, Mrs. W. H., 39
Thorndyke, Herbert, 3
Thorndyke, John, 3
Thorne, Edwin, 9
Tintoretto, Jacopo, 30, 58
Tissot, James, 21
Titian, 46, 58, 67
Tomplinson, Mary Jane, 23
Turner, Joseph M. W., 30, 51, 54f., 58
Twachtman, John H., 25

Vassar, Matthew, xiif., 10ff., 16
Vassar College, 11f.
Veronese, 58, 67
Viollet-le-Duc, Eugène E., 58, 62, 64f.

Watteau, Antoine, 67
Whistler, James, 13f., 32, 34, 46, 50, 55
White, Gilbert, 74
Whittredge, Worthington, 7
Wight, Peter B., 19, 61
Willems, Florent, 21
Williams and Stevens, 5
Worcester, Alfred, 57
Wyant, Alexander H., 65

ILLUSTRATIONS

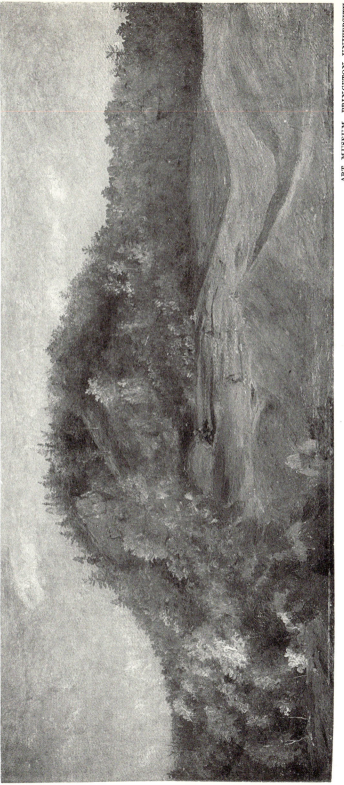

Fig. 1. *Upland Pasture* (oil)

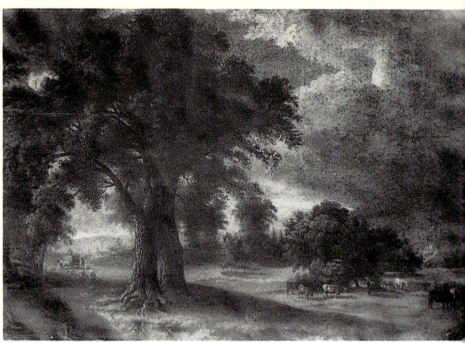

Fig. 2. *Juvenile Landscape* (oil)

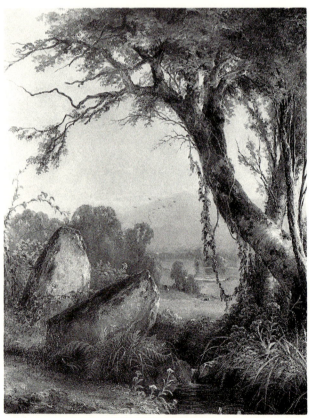

Fig. 3. *In Berkshire County* (oil)

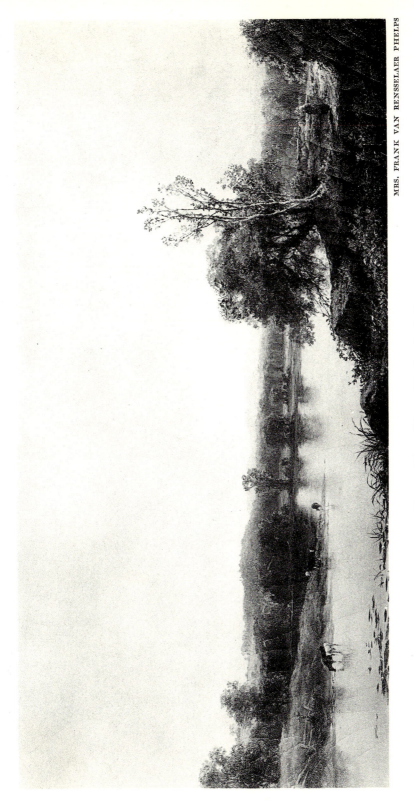

Fig. 4. *River View with Cattle* (oil)

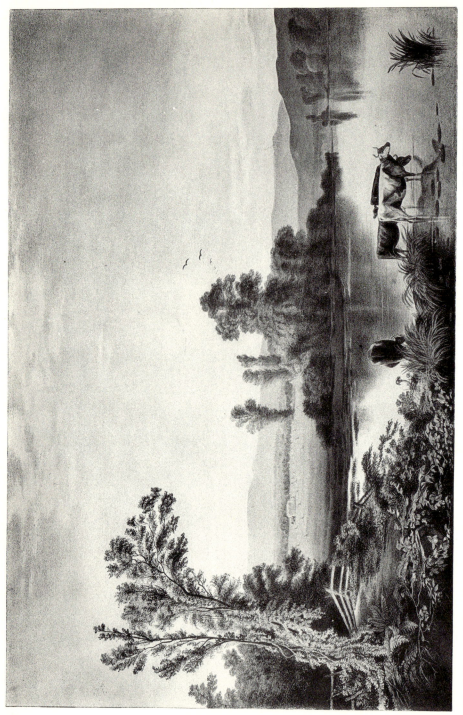

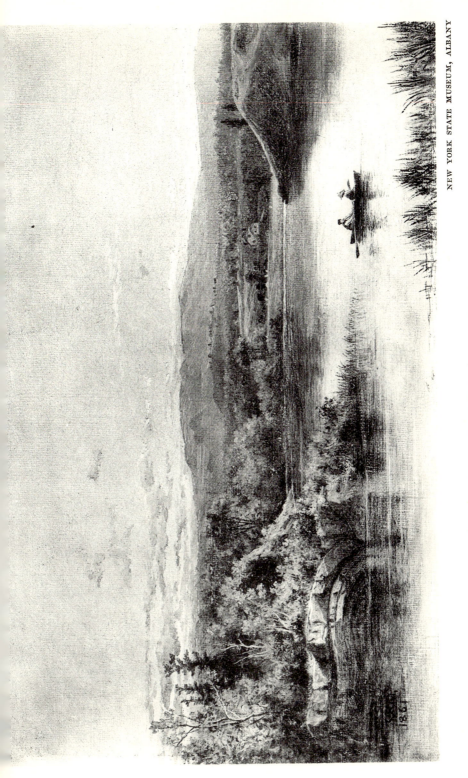

Fig. 6. *Catskill Bywater* (oil)

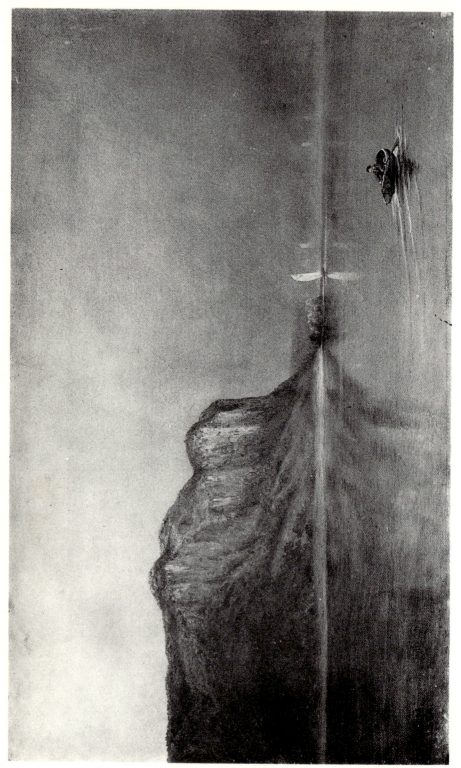

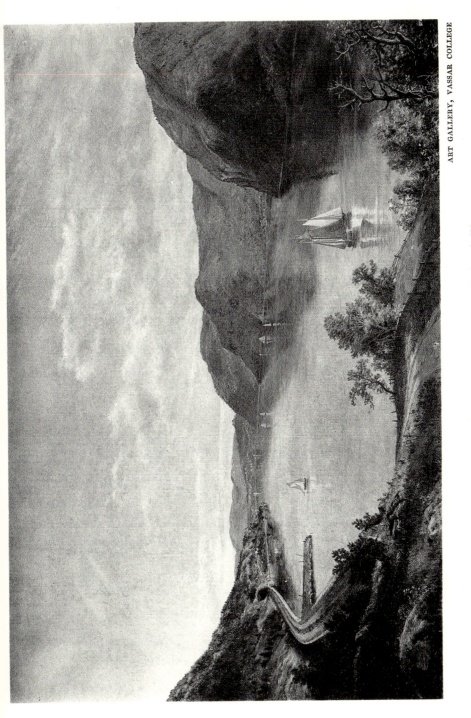

Fig. 8. *Down the Hudson to West Point* (oil)

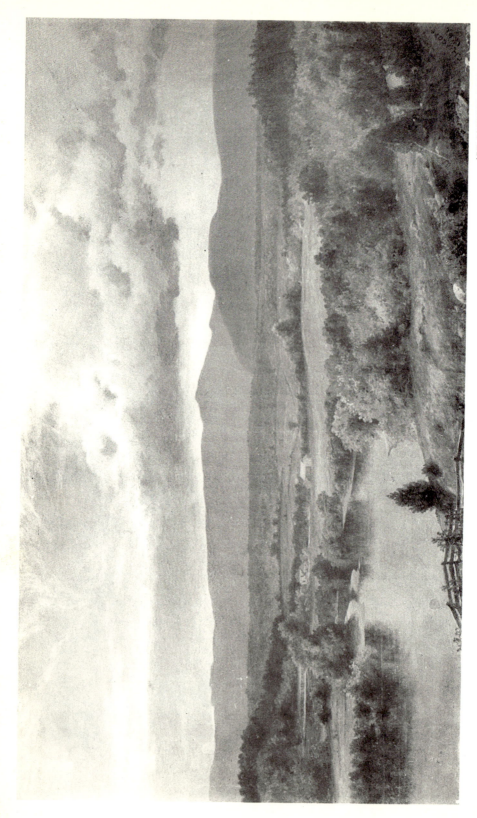

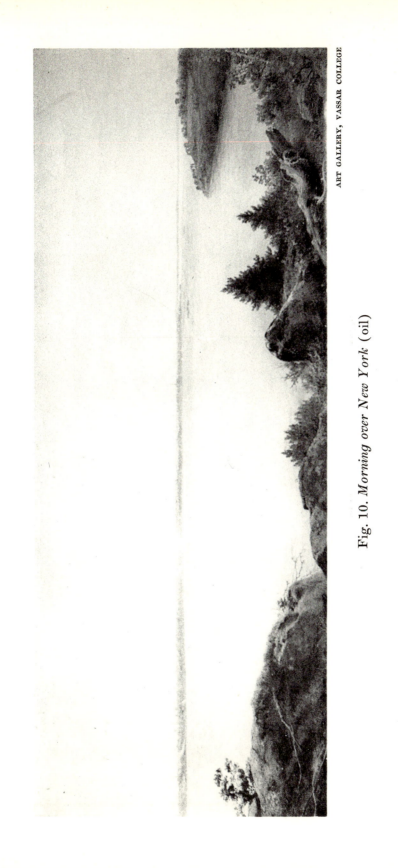

Fig. 10. *Morning over New York* (oil)

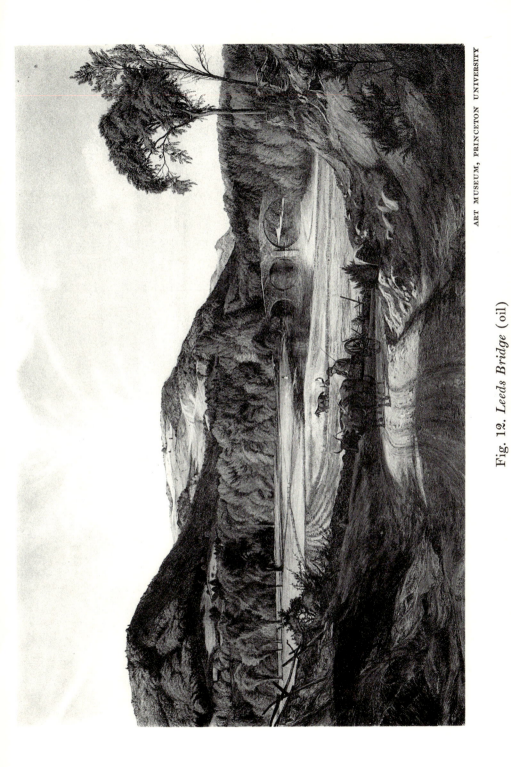

Fig. 12. *Leeds Bridge* (oil)

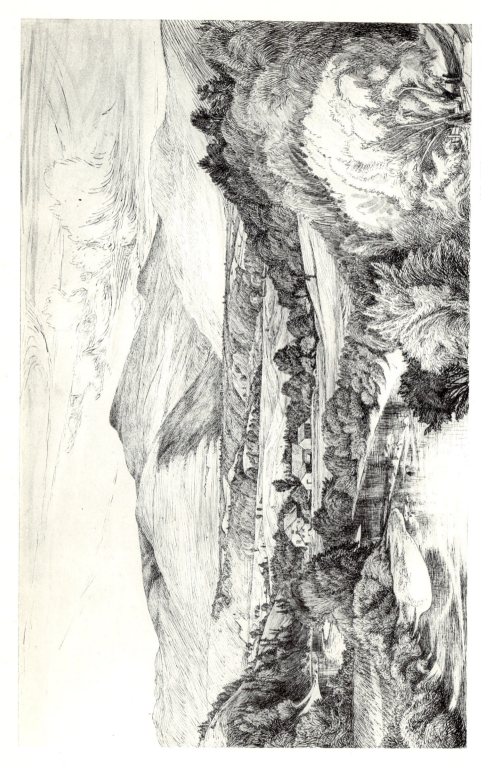

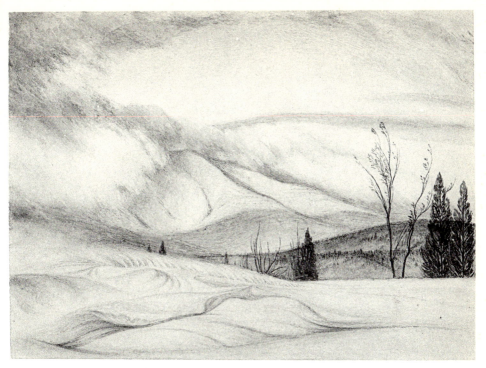

Fig. 14. *Snow Squall* (watercolor)

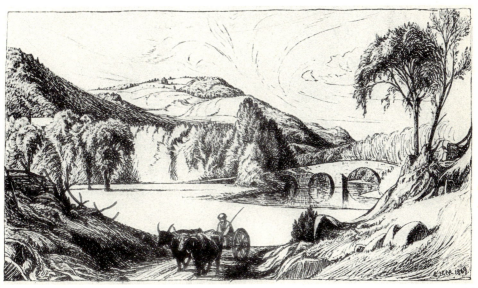

Fig. 15. *Leeds Bridge* (pen drawing)

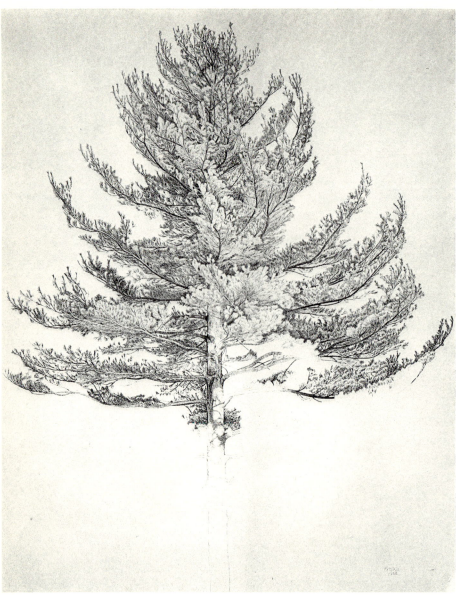

Fig. 16. *Pine Tree* (pen drawing, unfinished)

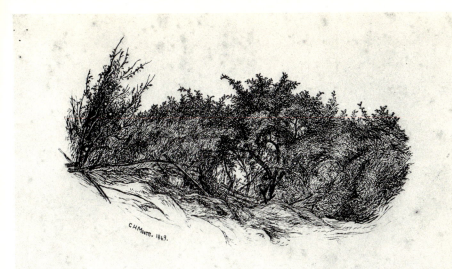

Fig. 17. *Overgrown Wood Road* (etching)

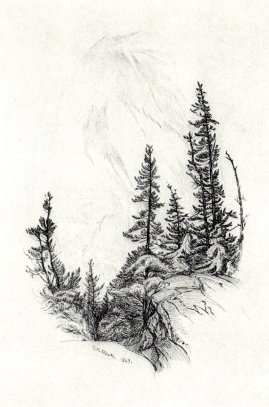

Fig. 18. *Ledge and Spruces* (etching)

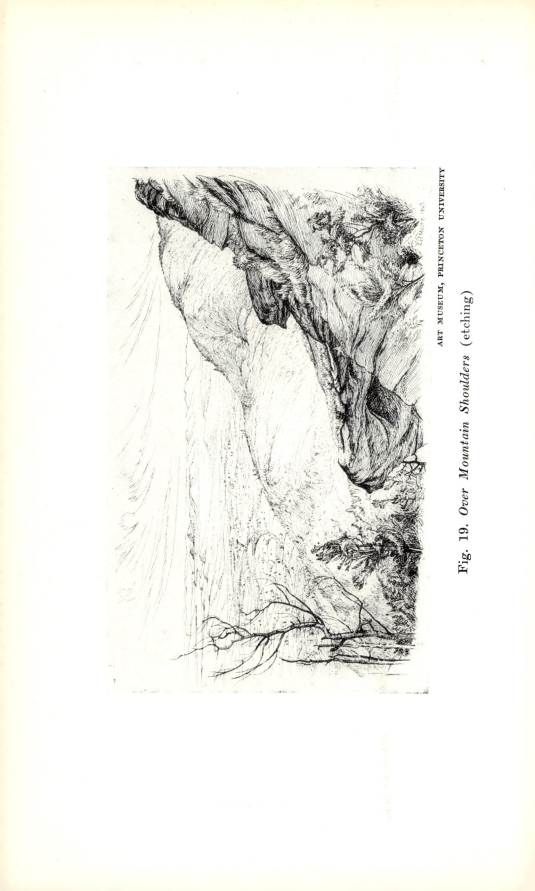

Fig. 19. *Over Mountain Shoulders* (etching)

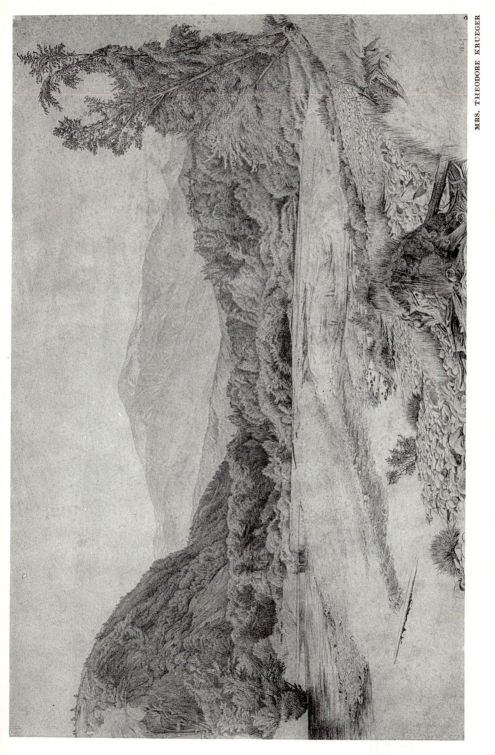

Fig. 20. *Mount Washington* (pencil drawing)

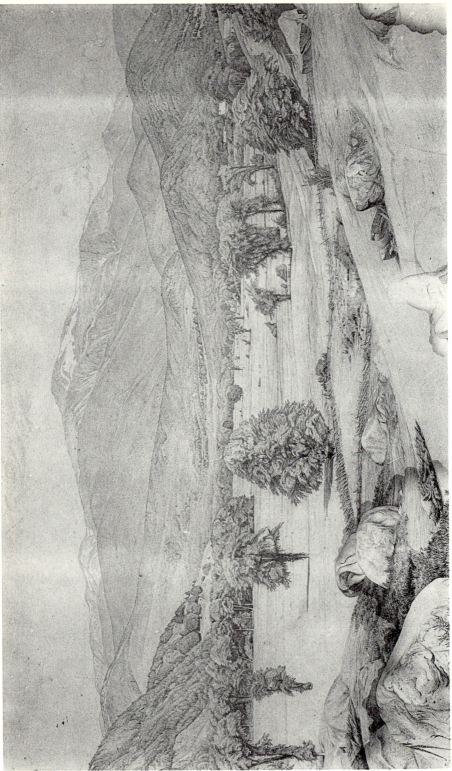

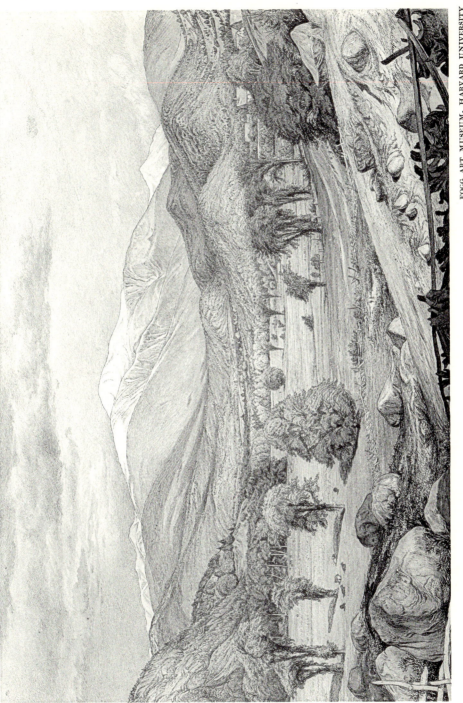

Fig. 22. *White Mountains* (pencil drawing)

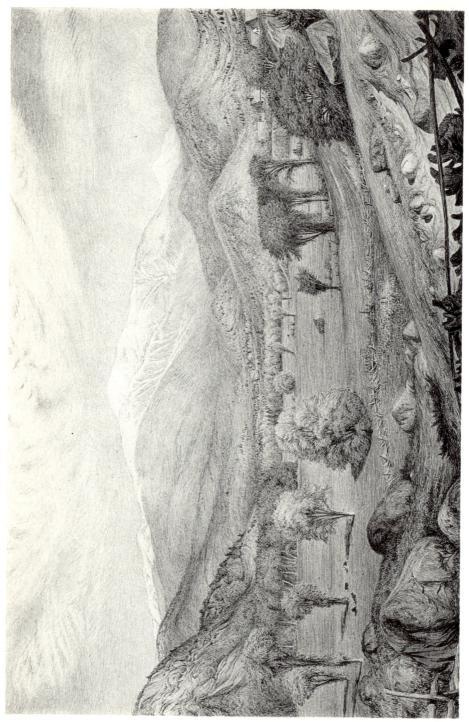

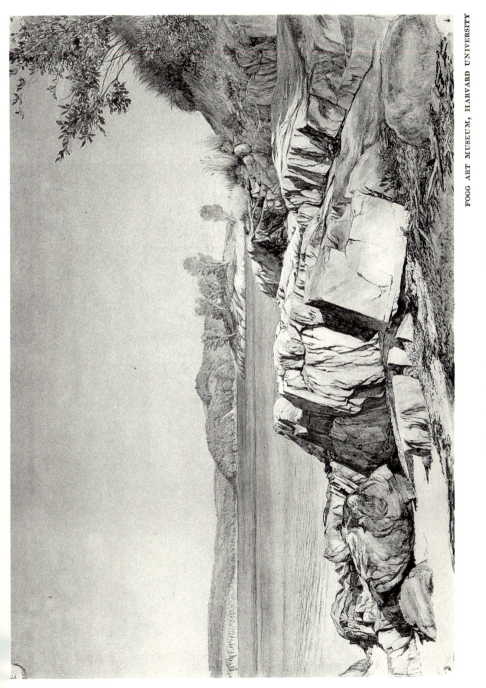

Fig. 24. *Landscape* (watercolor)

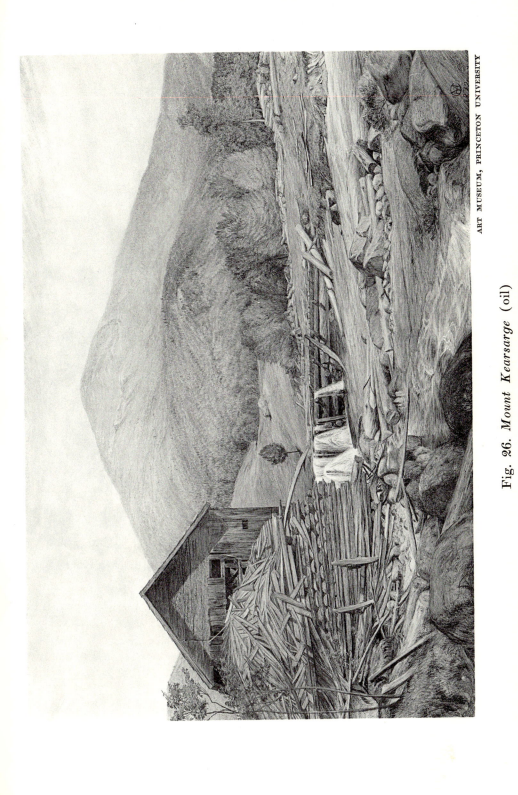

Fig. 26. *Mount Kearsarge* (oil)

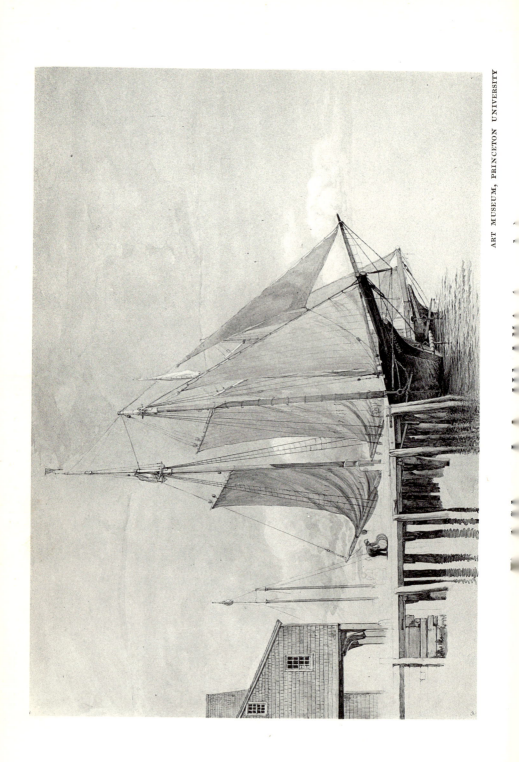

Fig. 28. *Sawmill at West Boxford* (watercolor)

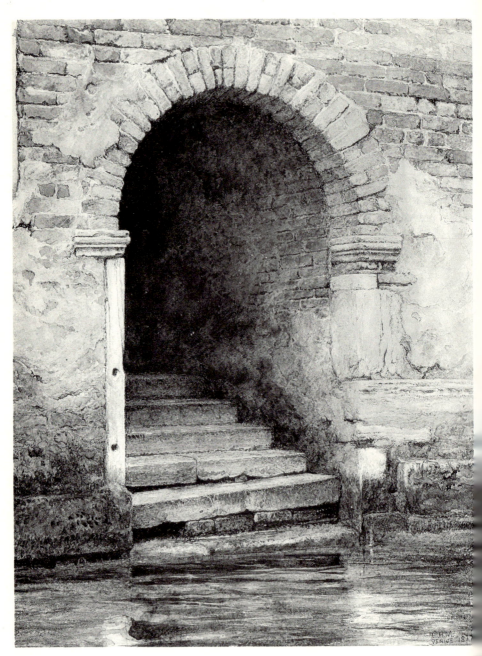

Fig. 29. *Venetian Doorway* (watercolor)

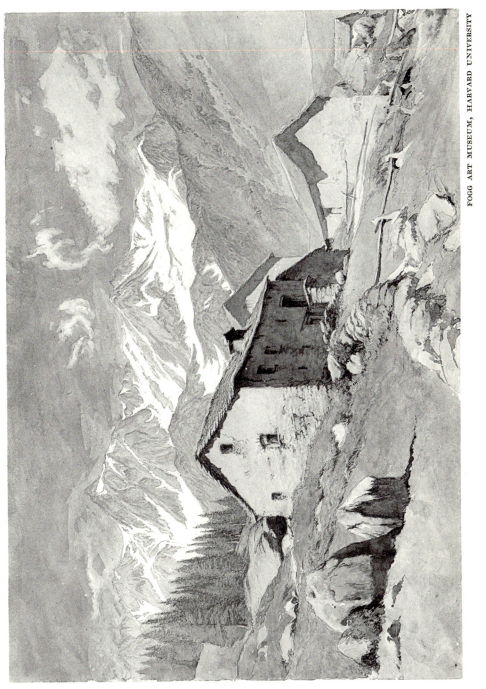

Fig. 30. *Near Simplon Village* (watercolor)

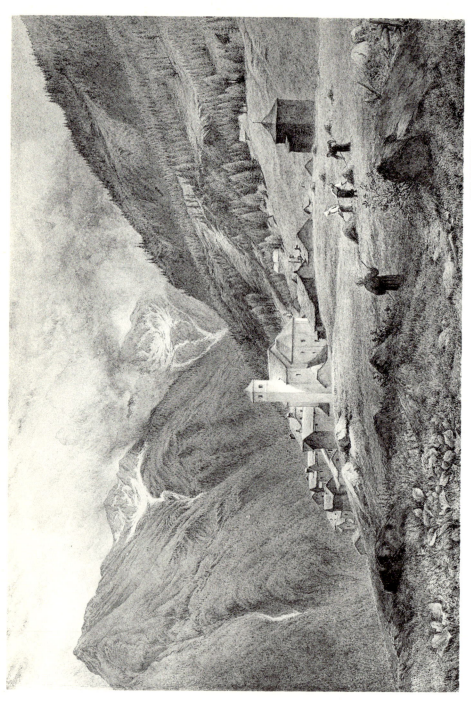

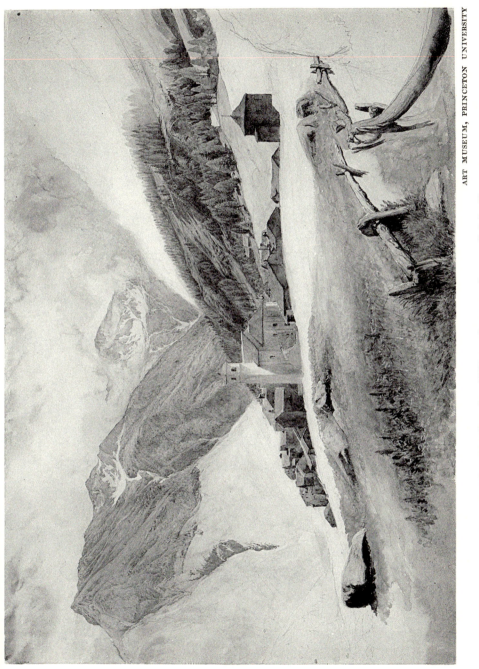

Fig. 32. *Simplon Village* (watercolor, unfinished)

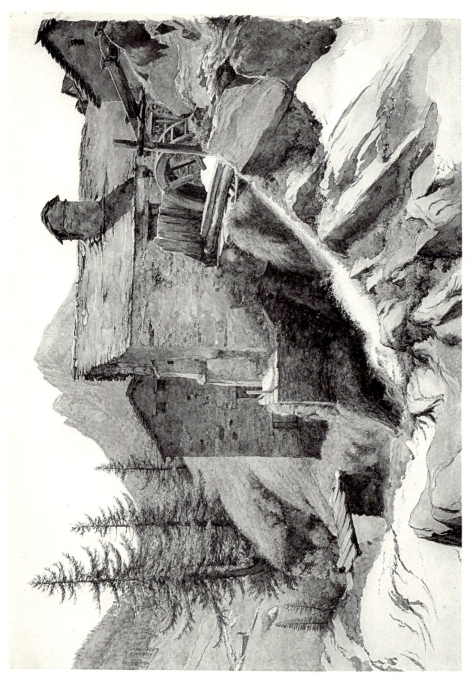

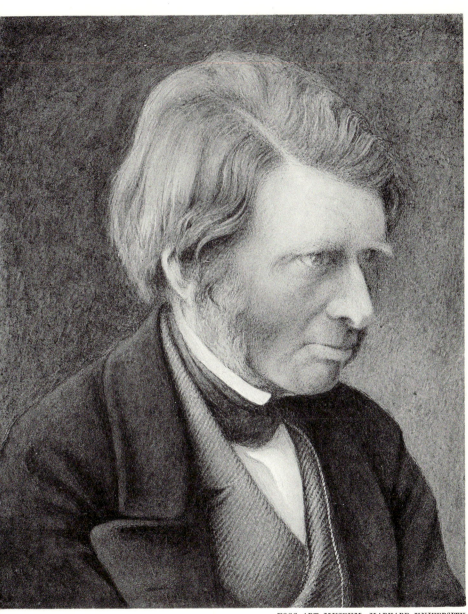

Fig. 34. *John Ruskin* (pencil drawing)

Fig. 35. *The Old Doorway, Venice* (mezzotint)

Fig. 36. *On the Lagune* (mezzotint)